THE

SKETCHBOOK
CHALLENGE

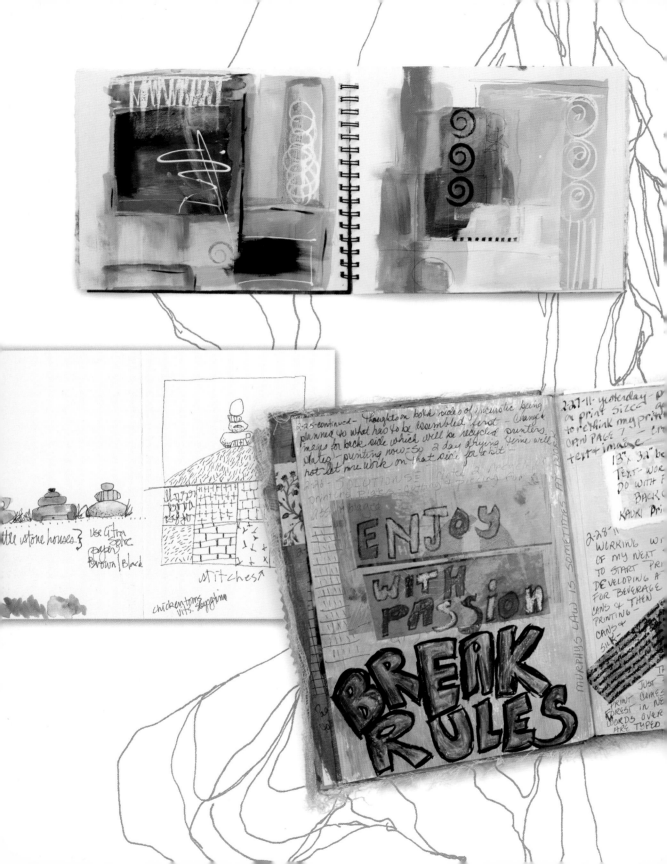

THE

SKETCHBOOK

CHALLENGE

Techniques, Prompts, and Inspiration for Achieving Your Creative Goals

SUE BLEIWEISS

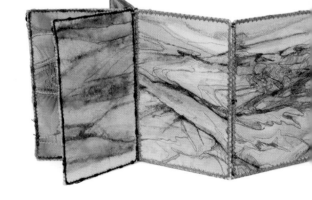

POTTER
CRAFT

NEW YORK

Published in the United States by Potter Craft, an imprint of the Crown Publishing
Group, a division of Random House, Inc., New York.

www.pottercraft.com
www.crownpublishing.com

POTTER CRAFT and colophon is a registered trademark of Random House, Inc.

Library of Congress Cataloging-in-Publication Data
Bleiweiss, Sue.
 The sketchbook challenge: techniques, prompts, and inspiration for achieving
your creative goals / Sue Bleiweiss.—1st ed.
1. Drawing—Technique. 2. Notebooks. I. Title.
NC730.B543 2012
741.2—dc23

ISBN 978-0-307-79655-4
eISBN 978-0-307-96554-7

Printed in China

PHOTOGRAPHER: Sue Bleiweiss
PHOTOGRAPHER ASSISTANT: Kathleen Murphy
DESIGNER: Danielle Deschenes

10 9 8 7 6 5 4 3 2 1
First Edition

ACKNOWLEDGMENTS

I owe a huge debt of gratitude to all of the artists who contributed their sketchbooks and artwork to this book. Thank you, Jill Berry, Jackie Bowcutt, Laura Cater-Woods, Violette Clark, Jane Davies, Jamie Fingal, Judi Hurwitt, Tracie Lyn Huskamp, Leslie Tucker Jenison, Lyric Kinard, Susan Brubaker Knapp, Lynn Krawczyk, Jane LaFazio, Kim Rae Nugent, Kelli Nina Perkins, Carol Sloan, Carla Sonheim, Kathy Sperino, Diana Trout, and Kathyanne White. Your contributions to the pages of this book truly make it a work of art. Many thanks to the artists who created the fabulous sketches for the theme Nature's Beauty: Jill Booker, Dion Fowler, Daniel T. Haase, Gina Macioci, Kathleen Murphy, Catherine Parkinson, and Dana Strickland. Thanks also go to Joy Aquilino for asking me to consider writing a book, to my editor, Betty Wong, for her guidance and help in refining the book's focus and putting it all together, to assistant editor Caitlin Harpin, and to designer Danielle Deschenes. And finally to Scott: thank you for your support and encouragement, which give me courage to follow my creative path and explore all of the challenges along the way.

CONTENTS

Corset Series
Heavy metal corset
...ishments.

How many times have you purchased a blank book with a beautiful cover and then tucked it away on the shelf because you thought it was too pretty to write in? Maybe you never thought about keeping a sketchbook because you believed they were only for serious artists. Or perhaps you opened the book, looked at the blank page, and wondered, "Now what do I do?" You want to fill the page, you just don't know what to fill it with.

It doesn't matter if you're just getting started on your artistic journey or if you've been at it for years; keeping a sketchbook is one of the most valuable tools in your artistic tool box. And as with any tool, you can learn to use it more effectively. Flip through my sketchbooks and you'll find that they are filled with ideas, inspiration, and experiments that I use as a jumping-off point for new artwork. My sketchbooks are messy and unorganized and packed with a combination of line drawings, paint splatters, lists, and notes. Not an end result in themselves, my sketchbooks are the beginning of my art-making process and very often guide me to achieving a creative vision first brainstormed on their pages. The idea for my corset series is a perfect example of this. I was pasting photos I had taken of textured, rusty surfaces into a sketchbook and started thinking about the history of each surface. That in turn led to thoughts of old clothing and styles of dress in the late 1800s, which in turn sparked the idea of exploring the contradiction of the uncomfortable corset against all those layers of fabric. And so I began a series of corsets created from a very lightweight silk fabric altered with paint to resemble hard, cold surfaces like rusted metal or stone.

Even though I've been a full-time artist for more than ten years, the fact is that it is all too easy to feel stuck, blocked, or uninspired when I stare at that blank page. If you've picked up this book, there's a good chance that you have experienced the same problem and are looking for a solution. This book invites you to put your sketchbook to good use. It is a guide filled with tips, hints, and tutorials to help you start and keep a sketchbook. And since a sketchbook is the launchpad for new art, the book also explores the process for translating your drawings, paintings, doodles, and notes into a finished piece of work.

In late 2010, I began the Sketchbook Challenge blog. It was an idea born from my resolution to keep a better, more consistent sketchbook. And because I had previously found that using themes in my sketchbooks helped keep me focused, I decided to invite

some of the best artists I knew to participate in a monthly themed sketchbook challenge. Each month a new theme would be announced by an artist alongside pages from his or her private sketchbooks reflecting this theme. Others would be invited to participate by posting their own sketchbook pages. The idea came to me on a Friday and by Monday the Sketchbook Challenge blog was born. Word started to spread and by the end of the month, the blog had more than 43,000 visits, surpassing all my expectations. Now people from all over the world, working in all different mediums and at all artistic levels, are playing along with the challenges each month. It has been incredibly inspiring to see such a diverse mix of work and extremely motivating to see how the challenges have helped people find a new way of looking at their sketchbooks.

My goal with this book is to show you that there are many ways to approach keeping a sketchbook and that there is no right or wrong way to do it. Like the online challenge, this book showcases artists exploring different themes, and you'll get an intimate look at the sketchbooks of some wonderful working artists. But this book takes it one step further to show you the artwork inspired by the sketchbooks, so you can see the creative process from start to finish. I've also

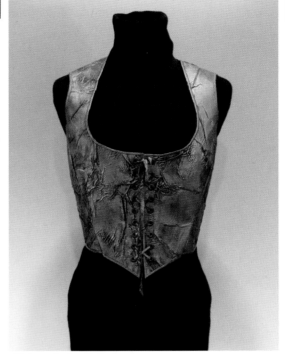

Silk Corset by Sue Bleiweiss

included an introduction to techniques that these mixed-media artists use in their sketchbooks and art pieces that will inspire more ideas for how to move visual concepts and brainstorms off the pages of your sketchbook and into finished pieces of art.

I hope that this book will not only encourage you to look at keeping a sketchbook in a new way but also inspire you to use it to help you explore and achieve your creative visions.

I wish you the best in all your creative endeavors!

{ *Sue Bleiweiss* }

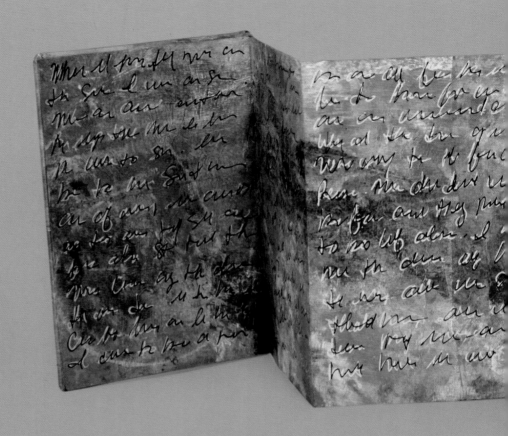

GETTING
STARTED

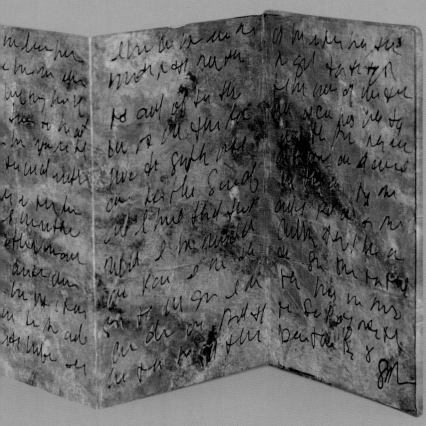

Accordion book created by folding a single sheet of paper (page 14)

AN OVERVIEW OF TOOLS AND MATERIALS

Keeping a sketchbook doesn't require a lot of fancy expensive supplies and tools. In fact, all you really need are some paper and a pencil, but you may find that you're more inclined to use your sketchbook if you have options other than just a pen or pencil to work with. Take a trip to an art-supply store and you'll find not only many different paper types to choose from but different book formats as well.

Types of paper

PAPER

When it comes to paper, there are many options to choose from, and trying as many as you can is the best way to find which ones you prefer. Keep in mind, however, that not all paper types can be used successfully with every medium. For instance, you wouldn't want to use paints on thin sketch paper that's more suitable for pen and pencil work. If you know that you will be working with a wet medium in your sketchbook, choose a heavier weight paper that will be less likely to tear, curl, or buckle. If you happen to find a sketchbook that you just absolutely want to use, but the paper is too thin for the medium you want to work with, then glue the pages together in groups of two or three to give them the body they need to hold up to water-based paints and inks.

WATERCOLOR PAPER comes in three surface types: rough, which has a very prominent textured surface; cold press, which is textured but not as much as rough paper; and hot press, which has a fine-grained surface that has almost no texture at all. The amount of surface texture will vary with each manufacturer and brand, so experiment with several different ones to find the one you like working with. Watercolor paper also comes in three different weights: 90 pound, 140 pound, and 300 pound, which is the sturdiest. I prefer a sketchbook filled with 140 pound watercolor paper when working with acrylic paints, watercolors, and collage because I know the paper will hold up to several layers of paint and glue.

DRAWING PAPER is a lighter weight than watercolor paper and has a nice smooth surface suitable for pen, pencil, and ink work. It will stand up to a light wash of paint, although it may curl as it dries. You can flatten it with a quick press with a warm iron but be sure to use a sheet of parchment paper as a press cloth to protect the soleplate of your iron.

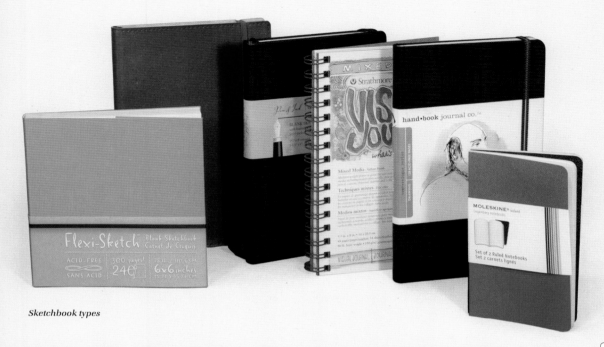

Sketchbook types

SKETCHING PAPER is thinner than drawing paper and is good for pen and pencil work. Not meant for using for finished artwork, it's meant to be used as practice paper for sketching. You can use it as a base for collage work or try painting it with a light wash of color and tearing it into strips for pasting into your sketchbooks for a splash of color on the page.

CANVAS PAPER by Strathmore is another favorite of mine. This heavyweight paper has a textured surface that mimics canvas beautifully, and the textured surface adds a nice level of dimension when painted. Canvas paper is a great surface for watercolor and acrylic paint.

PASTEL AND CHARCOAL PAPERS have a nice toothy surface that gives the charcoal and pastels something to grab on to. You can use other mediums on these papers as well, but if you want to work with pastels or charcoals, then you'll want to use this paper for the best results.

These are just a few of the options you'll find available in the paper aisle at the art-supply store. Experiment with a variety of papers to find the ones that give you the results you want.

SKETCHBOOK FORMATS

There are many different styles of sketchbooks and the one you use is really a matter of personal taste. They come in a multitude of sizes and paper types (including landscape or portrait layout) that vary from brand to brand, so always open a sketchbook and feel the paper inside before you buy it to make sure that it will be suitable for the medium you want to use in it.

HARDCOVER SKETCHBOOKS have the advantage of being sturdy and holding up well to being tossed in a bag and carried from place to place, but most don't lay flat. Hardcovers are a good choice for field sketching because the covers provide support for the pages.

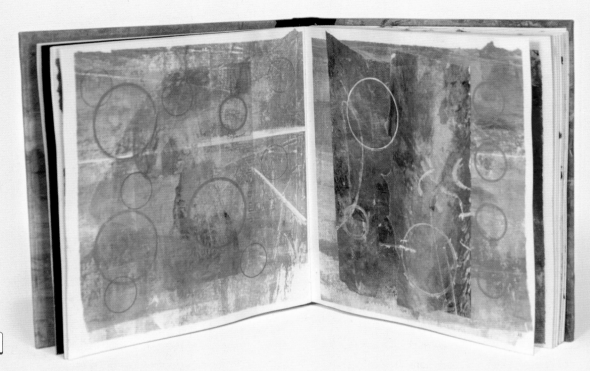

Repurposed hardcover book

PAPER-BOUND SKETCHBOOKS are flexible and, depending on how they are bound, will lay almost flat when opened. If you like to work across the width of two pages in your sketchbooks, then you'll enjoy working with a paper-bound sketchbook.

SPIRAL-BOUND SKETCHBOOKS lay flat when opened and you can fold the book back on itself, making it easy to turn the book and work on it from any direction. The drawback to a spiral-bound book is that the spiral itself makes it a challenge to work across the book in a two-page-spread format. There are many reasonably priced spiral-binding machines available these days, making it easy and economical to create your own sketchbooks using any type of paper you want.

Accordion Book

If you're looking for something larger in which to sketch, you might try an accordion book, which is made from one long piece of paper folded accordion-style. This is a great style to work in when exploring one particular theme and makes a nice presentation when displayed as an art piece itself. Accordion books are easy to make and can be sized to fit your needs. To make one, just cut a long length of heavier weight paper, fold it in half lengthwise, and then accordion fold it, which will result in a sturdy book with a fold along the top.

Loose Pages

Another option for your sketchbook is to work with loose pages. I do this a lot because I like the

convenience of working on smaller pieces of water-color paper that I can then paste into a purchased sketchbook, create a handmade book with, or spiral bind into a book using a binding machine. The single sheets give me a lot of flexibility for working with wet media because I don't have to wait for the paint to dry before starting on the next page.

Fabrics

Using fabric in your sketchbooks is a great way to add a tactile quality to your pages. Because I work primarily with fabric in my artwork, I have a lot of leftover scraps from larger projects and I frequently use these to create fabric collages in my sketchbook. I pretreat my scraps with a layer of Mistyfuse fusible web so that I can attach them to the page using a warm iron. A glue stick or a very light coating of liquid glue on the back of a piece of fabric will work as well. Consider using found fabrics from old clothing or linens. These can add not only a textural quality to your sketchbook but a personal one as well.

MARK-MAKING TOOLS

Pencils

Graphite pencils come in a range of hardnesses. The harder the pencil lead, the lighter and finer the mark it will create. When shopping for pencils, you'll find that they come graded in three levels—H for hard-ness, F for fine point, or B for blackness—and each of these letters will be accompanied by a number ranging from 2 to 9. So pencils labeled from 2H to 9H will have a hard point and produce a finer line, with 9H being the hardest option. Pencils labeled 2B to 9B will have a softer point and produce a thicker darker line, with 9B being the softest option. Jill Berry offers an excellent guide to sketching with

You can take a more innovative approach to keeping a sketchbook by altering an old throwaway library book (and saving it from being tossed in a land-fill). If the pages are thin, glue them together in pairs and then brush white gesso on the pages to obscure the text below, giving the page a nice "tooth" that will allow you to use paint, ink, or pencil to make your marks on it. If you like to work with collage in your sketchbook, tear a few pages out of the book to make up for the bulk that you'll add later. Save those pages and use them in collages.

Many of the artists in this book like to make their own sketchbooks to work from. These range from simple folded and stitched pamphlet styles to altered books and spiral-bound. You can find resources for several bookmaking tutorials on the Sketchbook Challenge website at http://sketchbookchallenge.blogspot.com/p/tutorials.html.

Graphite pencils

various pencils in her four-step drawing of a cabin (page 139). Pencils, like paper, vary from brand to brand, so again, it's worth experimenting with several to find your favorites.

Crayons

Colored Pencils

Colored pencils are available in three types:

WAX PENCILS are created by binding pigment with wax. These are easy to work with and are the most common pencils found in the arts and crafts stores. You'll find a lot of different brands, ranging from student and craft to artist quality.

OIL PENCILS use vegetable oil as the binder and are generally slightly harder than the wax-based pencils.

WATER-SOLUBLE pencils are created with either wax or oil and have an additive that allows the pigment to be liquefied when brushed with water, creating a watercolor effect.

Markers and Pens

Markers come with tips ranging from fine to thick as well as chisel tip for calligraphy work and fine-point

to ballpoint pen tips. Permanent pens will allow you to draw or write with them and then go back in later and add a wash of water or paint to your drawing without causing the ink to smudge or run. Which pen to use is really a personal preference. Micron Pigma pens are my favorites. They are permanent, come in a range of tips, and the ink is archival, so there's no concern about acid in the ink degrading the paper over time. Micron pens are pigment based, not dye based; because pigment

Colored pencils

A selection of paints for paper and fabric

molecules are 100 times bigger and more chemically complex, they last longer, which makes the ink less likely to be affected by UV rays or to fade.

Calligraphy Pens

Calligraphy pens are available as dip pens or with ink-filled cartridges. Inks are available in a rainbow of colors as well as black and sepia. Most pens have interchangeable nibs so you can vary the size of the marks they make. I often use these in my sketchbook to draw with because I like the wispy effect that I can get by varying the pressure and angle of the pen.

Crayons

Crayons can be a quick and easy way to add color to your sketchbook pages. Like colored pencils, crayons vary in grade, hardness, and quality depending on the type and brand; both wax and water-soluble types are available. Wax crayons are water-resistant

and won't be affected if you add a layer of watercolor over them. Water-soluble crayons liquefy when you brush water over the surface they've been applied to.

PAINTS AND INKS

Essentially, you can use any paint you want on paper or fabric, though the choice you make may have unintended consequences, so it's good to educate yourself about different types of paints and how they behave when applied to different surfaces. Before investing in a lot of new paints, try one or two and test them on the paper or fabric that you want to use to see if it gives you the result you want.

Paints and Inks for Paper

ACRYLIC PAINTS are water-soluble and can be used as a transparent wash or an opaque covering for your pages, depending on how much water you

mix with the pigment. Keep in mind, though, that a thick layer of acrylic paint will take longer to dry and may cause your pages to stick together even after they've dried.

WATERCOLOR PAINTS are available in pans or tubes and also in liquid form and are a great way to add transparent color to your pages either before you draw on them or after. When using watercolors to add color to a page you've drawn on, be sure that you've used a drawing medium that won't bleed when the watercolor is brushed over it.

ACRYLIC INKS can be used right from the bottle and applied using dip pens, brushes, and, in some cases, airbrushes. They can be diluted with water and used just as you would a watercolor paint. You'll find them in transparent, opaque, and pearlescent colors.

CRAFT INKS come in easy-to-use spray bottles and are another great way to add color to your sketchbook pages. They're available in a wide variety of colors and types, dry fast, and work well with stencils and masks or resists (page 45).

Paints for Fabric

When choosing paint for a piece of fabric that will be laundered, it's important that the paint can be heat set or fixed to the fabric so that it won't wash out. There are a lot of manufacturers of textile paints, and most offer paints available in transparent and opaque and even a metallic or pearlescent version. Keep in mind that a thick application of any of these paints may change the feel of your fabric and make it a challenge to stitch. The advantage to these heavier paints is that they work beautifully for techniques such as screen printing and rubber stamping.

If you want to add color to your fabric without changing the feel of it, then consider using a thinner dye-like paint such as Jacquard Dye-na-Flow or Setasilk silk paint, which are very fluid. They're typically used for painting on silk, but that doesn't mean you can't use them on other fabrics.

GLUE AND ADHESIVES

Collage can be a great way to explore themes in your sketchbook, and you have several options when it comes to choosing an adhesive to secure your collage elements to your pages. Glues and adhesives vary in quality, thickness, and form, so before you grab just any old glue for your collages, first consider all the options available.

PVA or Liquid White Glue

PVA (polyvinyl acetate) glue is widely available and ranges from very thin and watery to very thick depending on the brand. Most dry fast and clear, but it pays to test the glue before using it on your project if you're not sure. Most PVA glues are not acid-free, so if longevity for your project is a concern, be sure to check first that the glue you're using is acid-free. If you want an acid-free PVA glue, look for bookbinding glue, such as the one sold by Hollander's School of Book and Paper Arts (http://hollanders.com/).

Paste Glue

Paste glues come in tubs and sticks. Apply the tub version using a stiff brush, palette knife, or craft stick. Glue sticks are a great option when working with a paper too thin for liquid glue. A common mistake when working with paste glue is to use too much and spread it too thickly, which causes bumps and wrinkles. Look for the word *permanent* on the label to ensure your collage elements will stay put.

A selection of adhesives

Spray Glues

Although spray glues are another option when you want a thin adhesive, you must take great care when working with them. Use them only in a very well ventilated area away from other people and pets.

Fusible Webbing

Fusible webbing is designed for use with fabric and uses the heat of an iron to activate it. It also works with paper and is a great alternative to liquid glues, especially for fragile papers. I prefer to work with Mistyfuse fusible web because it's very lightweight, sheer, and doesn't add any bulk (which is preferred when working with lightweight sheer papers) but creates a strong bond.

Gels and Mediums

There are several companies that manufacture product lines of gels and mediums, and in general these are intended to be added to acrylic paint to either thin, thicken, or otherwise change its texture or opacity. These can also be used as an adhesive for collage.

Fixatives and Varnishes

Fixatives and varnishes come in a variety of types and can be used to protect artwork from smudges and environmental damage such as that from dust, smoke, and UV light. They are available in both permanent (nonremovable) or workable (usually with turpentine or mineral spirits) varieties as well as liquid or spray forms and different sheens ranging from matte to glossy.

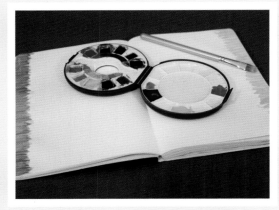

Brush the excess paint off your brushes onto pages of your sketchbook.

Paint just the edges of your sketchbook for a splash of color.

ADDING BACKGROUND COLOR

Writers fear the blank page and artists fear the white page. That plain, smooth, stark page can stop your creative flow in its tracks. To counteract this, try adding some color with paints or ink to your sketchbook pages before you do anything else.

An easy way to do this is to keep a blank sketchbook next to you when you're painting something else and offload the extra paint on your brushes and palette onto the sketchbook pages. Before you know it, you'll have a sketchbook filled with colorful pages just waiting to inspire you.

Sometimes I like to go through my sketchbook and just add a bit of color along the edge of each page using watercolors. The splash of color gives the page a less intimidating feel while still leaving me plenty of white space to work in.

Spray inks are a great way to add color to your pages because they dry relatively quickly. Also, you can add a bit of imagery at the same time by placing a stencil on your page before spraying on the color.

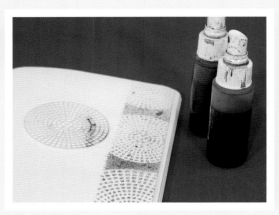

Use spray inks and stencils to add imagery to the page.

Use a purchased stencil if you have one or use found objects from around the house. Rug canvas, netting from fruits and vegetables, and even torn pieces of scrap paper can be used. Anything you can lay on top of your sketchbook page and spray over or through can be used as a stencil or mask.

If you'd like your pages to have an earthy vintage look, then you can stain them. Brew some really strong coffee or tea, let it cool, and then brush it onto your pages. Or for a more speckled look, pour some in a spray bottle and lightly mist the pages.

LOOSENING UP

Okay, so you've got your sketchbook ready and your pen in hand, and you want to start working, but you're having a hard time actually putting the pen on the paper. You might find it helpful to do some loosening-up exercises first. These are easy and fun and a great way to just get your hand moving across the page.

Doodling

There's no right or wrong way to doodle and everybody has their own style. You can doodle things, faces, and shapes such as circles and squares filled with lines and patterns. It doesn't matter what you doodle as long as it gets you making a mark on the page, but if you're stuck and you just can't seem to get moving, try my favorite doodle exercise, which I learned from artist Diana Trout.

- Open your sketchbook to a blank page, place your pen on the paper, and start drawing a line. Without crossing over your lines, continue drawing until you've filled the page.

I doodled one continuous line over the page and then colored the edge with a black marker.

- Once you're finished, take a look at the page and see if you can identify any shapes you'd like to enhance with some additional details.
- Turn the book and look at it from different angles.
- Try coloring in your doodle along the edges with a black marker or some ink.
- Consider using isolated sections of the doodle to create a silk screen or inspiration for a hand-carved stamp.
- Instead of using the whole page, consider doodling just along the edges.
- Try doodling simple objects or shapes, like leaves or houses, and then go back in and color with your colored pencils or watercolors.

Continuous-line, or contour, drawings are another great way to loosen up.

- Pick an object and begin drawing it without lifting your pencil off the page, using one single continuous line.
- Stick with simple objects and don't get hung up on the details. The point of this exercise is not to render the object perfectly; it's just to loosen up and have fun!

LEFT: *I doodled one continuous line around the edge of the page and then added simple details.*

Some one-line drawing ideas:

- Vase of flowers
- Tree
- Coffee mug
- Dog or cat
- House
- Car
- Bird
- Fish

BELOW: *I drew the houses using a Micron pen first and then colored them with watercolor paint.*

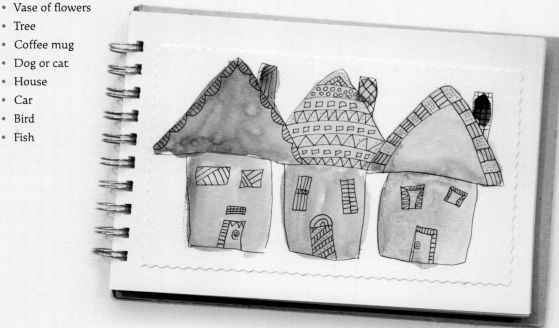

To expand on this loosening-up exercise, try drawing the object without looking at the paper.

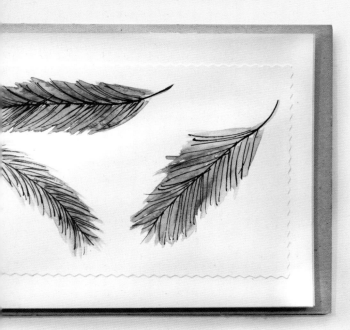

Nondominant-Hand Drawing

When you draw with your nondominant hand, you are forced to use a part of your brain you don't normally use when drawing. It also forces you to slow down and take your time. You'll find that when you draw this way your lines will become more fluid and loose because you're less likely to use short sketching motions.

Musical Marks

When all else fails, put on your favorite music and crank up the volume! Grab some paper and a marker, a paintbrush, or whatever your favorite mark-making tool is and let the music move your hand around the paper.

LEFT: *Drawing feathers is a great way to loosen up. I drew the feathers first and then added the color later.*

WORKING WITH THEMES

I love working with themes in my sketchbooks. Having a framework to work within takes the stress out of trying to decide what to do when I open my sketchbook. The theme acts as a guide and helps narrow my focus when it comes to which techniques I want to explore, especially when it is time to start the process of translating what's on the pages into a new piece of artwork. There's no right or wrong way to choose a theme to work with, and not all themes will speak to every artist. Personally I like to work in more abstract word themes such as those related to texture and structure because that's the style I like, but you may find that a more literal theme, such as houses, birds, or flowers, is more appealing. When I sat down to create the list of themes to use for this book, I tried not to think too hard about it and created a list of random words to use very quickly because I wasn't thinking about what each theme represented or meant to me. The goal was just to create a list of words I could present to the artists in the book to choose from. It would be the artists' job to explore the meaning of the themes and how it spoke to them. Don't dismiss a theme because nothing comes to mind when you first glance at it; give yourself time to think about it first and see where it leads you.

So how do you decide on a theme? Well, the idea for a theme can come from anywhere! What do you see when you look out the window? The natural world is filled with ideas for themes. Do you see trees, birds, bugs, flowers, a vegetable garden, leaves, animals, a snowy landscape? Any of those would make a great theme to explore. Take a walk around the neighborhood and see if something sparks your imagination. Notice how each house has a different entryway or door, suggesting the theme of passages or journeys. Looking at a mailbox

Stuck for Ideas? Try These

Pull out some old magazines or newspapers and cut out interesting words or phrases. Toss them into a paper bag, pull one out at random, and paste it onto your sketchbook page. Sketch whatever comes to mind when you read it. You could do a series of pages inspired by the same phrase, or pull a new one for each.

Phrases cut from magazines

- Google the phrase "random word generator" and let the computer generate one for you.

- Open the dictionary to a random page and pick a word from there.

- Take a trip to a local museum and spend some time looking at art, or visit the library and browse the art book section.

- Use a favorite quote, poem, childhood memory, or song.

- Are you a collector of teapots, figurines, stamps, vintage textiles, etc.? Use one of those as your theme.

- Or you can always visit the Sketchbook Challenge site for one of our monthly themes.

might make you think of communication, another great theme to explore. What about the textures that you see on your walk? The gravelly surface of the road, the color variations of the brick, the bark of a fallen tree, or the weathered beauty of a painted fence exposed to the elements for too long might lead you to explore different ways to illustrate texture in your sketchbook.

EXPLORING A THEME

Okay, so you've picked your theme. Now what? There are no rules about how to explore a theme in your sketchbook, and it's a good bet that every artist has a different method. You might be comfortable just jumping right in, opening your sketchbook, and getting to work. If that's the case, go for it! Creating a collage is another great way to begin: Spend some time tearing images from old magazines that relate to your theme and create a collage with them. You may find that the process of creating the collage sparks other ideas too.

I am an avid list maker, so I always start by making a list of all the things that come to mind when I think about the theme. Sometimes a theme is so abstract it can be hard to know where to start, and making a list helps me organize my thoughts and narrow my focus.

You might also try mind mapping as a way to get started exploring a theme if you're having trouble picking a place to start. This is a great way to get your ideas on paper and help you decide which direction to pursue. Mind mapping is like making a list but in a more structured format.

- Write your theme in the center of the page and then draw a box around it.
- Branch off from the center box into subcategories and continue to add more categories beneath those.

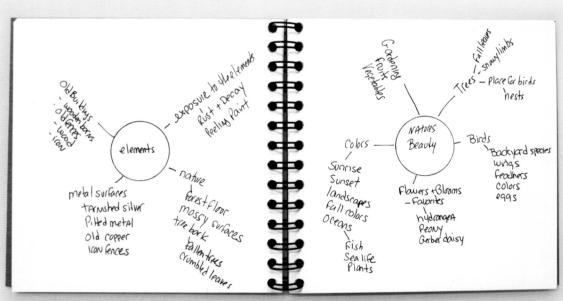

Mind maps for the themes Elements and Nature's Beauty

Hosting a Sketch-in

A sketch-in is an event where you gather with others and all work in your sketchbooks simultaneously. Collect your sketchbook and some sketching supplies and meet up with some friends at a local park, museum, library, or even in your own backyard. You can pick a theme and start sketching or begin with a warm-up exercise to get everyone loosened up a bit. The only rule for a sketch-in is to keep it a welcoming and encouraging environment where all skill levels and styles are welcome. It can also be a great opportunity to share or try out new drawing and sketching supplies with others.

Try your own mind map for these themes, and you'll see that yours will be different than mine, just as whatever imagery you create for it in your sketchbook will look a lot different than mine. For example, I asked seven different artists to create a sketch using "Nature's Beauty" as their theme, and each one created a drawing very different from the others. See the following spread for their variations on the theme.

Once you have your thoughts about the theme mapped out and have decided where your focus will be, you can jump into creating some visual representations of it in your sketchbook. Now's the time to break out your pens, pencils, markers, and paint! Open your sketchbook and start drawing, collaging, and painting, using your theme as your guide. If you like to take photographs, print copies of them and paste them into your sketchbook, or glue an envelope to a page in your book and then just tuck the photographs in. It's completely up to you how many sketchbook pages you create based

on the theme. Create one page or fill an entire book. The most important thing to remember here is that there is no wrong way to do this. Let go of any preconceived notions of what your sketchbook pages are supposed to look like and just have fun with the process of making marks on the page.

GETTING OFF THE PAGE

There is no right or wrong time to move off the sketchbook page and on to creating a new piece of artwork. You may decide that it's time after one page or it may take as many as a hundred. Once you do decide to make the transition, spend some time reviewing your sketchbook pages, making notes about the elements that you want to use and the techniques that you want to translate them with. You may find that you need to spend time making samples and experimenting to find the right technique to give you the results you want. Take the time to keep notes about this process in your sketchbook so that you can refer back to them when working on other projects and make sure to attach a sample piece of your experiments to your page so you'll also have a visual reference. Don't get discouraged if the technique you thought would work doesn't, because the lessons learned from the attempt may prove to be valuable information for future projects. And don't only keep notes about what doesn't work. When you find a technique that works, take a moment to jot down some notes about how you did it and why you found it successful.

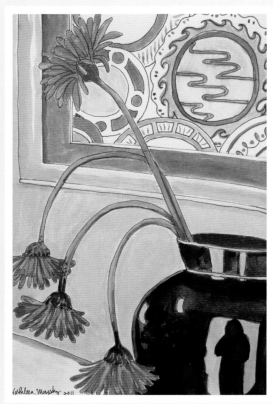

Blue Vase *by Kathleen Murphy*

Nature's Beauty *by Dion Fowler*

Nature's Beauty *by Catherine Parkinson*

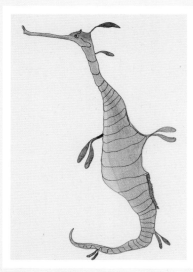

Sea Horse *by Daniel T. Haase*

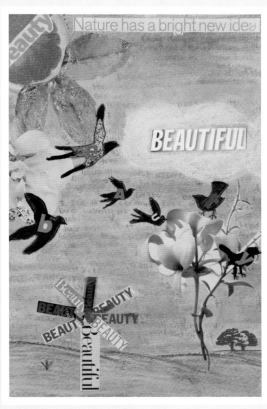

Nature's Beauty *by Gina Macioce*

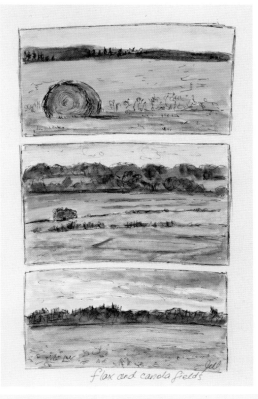

Flax and Canola Fields *by Jill Booker*

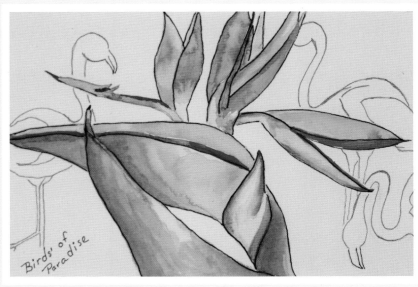

Birds of Paradise *by Dana Strickland*

Something about MARY

↖ SHOULD i include this saying in my MARY SHRINE?

sacred heart shows up in mary

SACRED HEART
SHOULD I include it in the ?

WHAt about ROSES?

stone houses? Use a thin paper spre Brown/Bla

Nature's Beauty

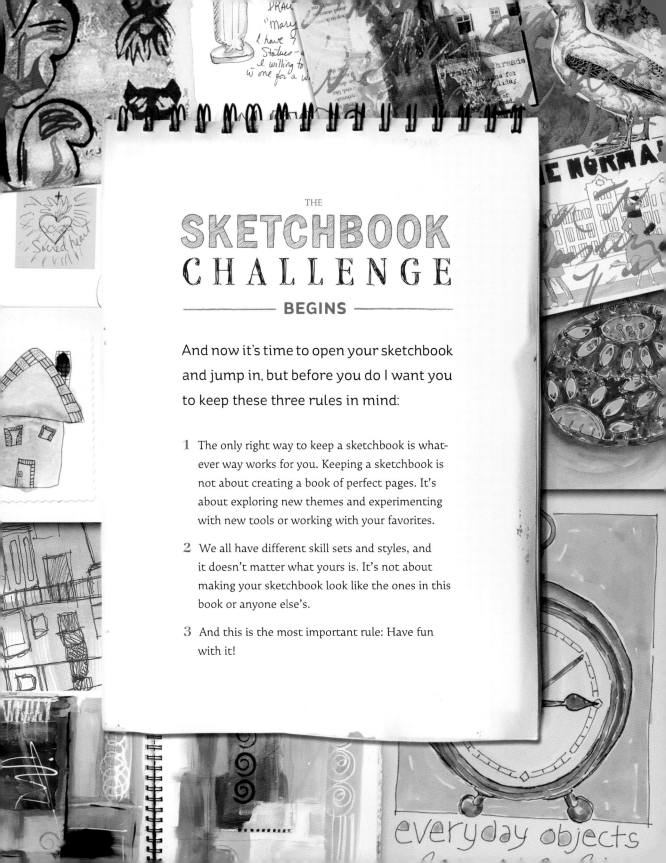

THE

SKETCHBOOK
CHALLENGE

—— BEGINS ——

And now it's time to open your sketchbook and jump in, but before you do I want you to keep these three rules in mind:

1 The only right way to keep a sketchbook is whatever way works for you. Keeping a sketchbook is not about creating a book of perfect pages. It's about exploring new themes and experimenting with new tools or working with your favorites.

2 We all have different skill sets and styles, and it doesn't matter what yours is. It's not about making your sketchbook look like the ones in this book or anyone else's.

3 And this is the most important rule: Have fun with it!

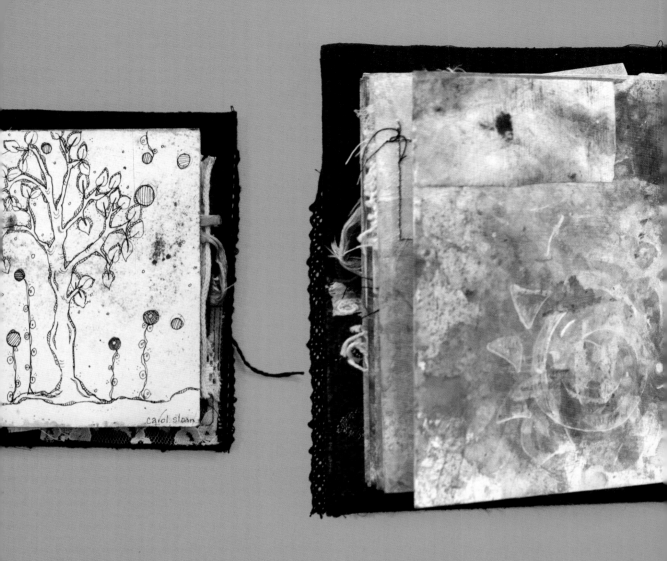

CIRCLES

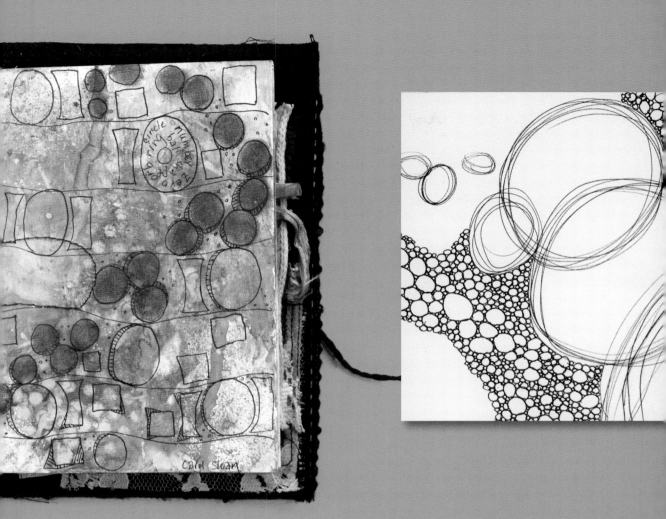

Carol Sloan

At first glance the word *circles* may seem like too ordinary a word to inspire a piece of artwork, but once you start to explore it, you'll find that it's rich with possibilities. Think of all the instances during your day that you encounter the circle shape (coins, plates, fruits, the sun and moon, etc.) or consider the ethereal nature of the circle with regard to the circle of life, time, and orbiting planets. You'll find that once you start looking for the circle shape it will start popping up everywhere.

Artist: **CAROL SLOAN**

Carol is a mixed-media fiber artist who tends to include a lot of experimental techniques in all her work. In her circles sketchbook, Carol uses a mix of traditional drawing and painting materials, as well as paper and fabric scraps, then translates her sketches into an embellished art book.

Techniques Used: **PEN & INK, COLLAGE, DIGITAL PRINTING**

My first thought about this assignment was "Great! I draw circles all the time! This will be easy for me to do." But there was more to the theme than just drawing circles. It made me think about how circular things surround us, how events in our lives run in a circular manner, how Mother Earth is circular. The sun. The moon. The seasons. Our lives seem to be surrounded by circles. The hardest part for me was narrowing down all of my ideas!

I've been making my own books lately, so I chose to make a special one for this theme. The cover has a print of a pen and ink drawing that I did of poppy seed–head shapes, circular shapes surrounded by more circular shapes in the guise of seedpods. I used tiny circles to detail and shade areas of the drawing. I used acrylic paint washes, made marks with stamps/masks/household items, ink pads, and collage elements, and added various scraps of paper and fabric to fill the sketchbook. Then I spent some time letting the pages "talk" to me. I tried to remain open-minded about the potential on each separate page instead of trying to force my own will on the page.

I was sitting outside sketching on a hot spring day. The sun was beating down on me; everything looked rather fuzzy, like one of those old Western movies where everything is blurry. I wanted to re-create this feeling in my sketchbook. I had already done some background painting on the pages, just waiting for the right subject to come along. I flipped through the pages until I found the perfect one. It was pink and yellow with areas of white and tan to show the spots (circles) that I kept seeing while I was outside. I drew the broken outline of the sun, trying to capture the feeling of the day's sweltering heat. Looking at the finished page, I realized that it would be perfect for the cover of a book (page 35, top left). It was a simple process to use the painted page at that point. I scanned it into the computer then printed it out on a heavy Exact vellum bristol paper. I applied a layer of workable fixative after the page dried. This kept the ink from smearing when I coated it with Golden soft gel medium (this seals the surface and makes the cover more durable). I used a smaller section of the scan for the back of the book. This is a great way to utilize your artwork in more than one place.

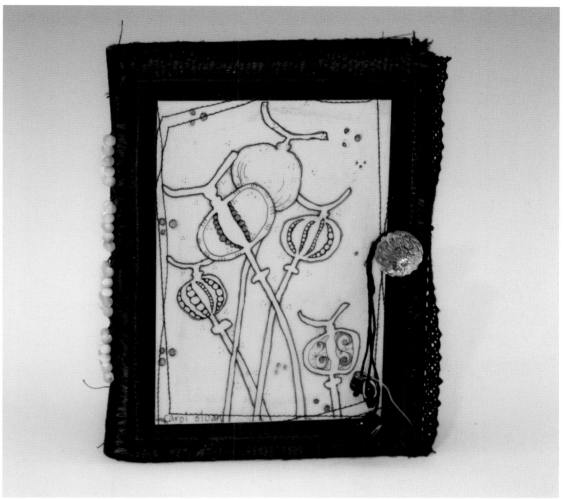

Cover of Carol's circles sketchbook

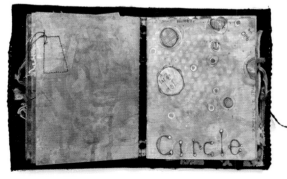 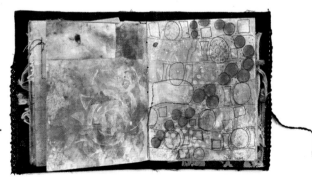

Circles sketchbook pages by Carol Sloan

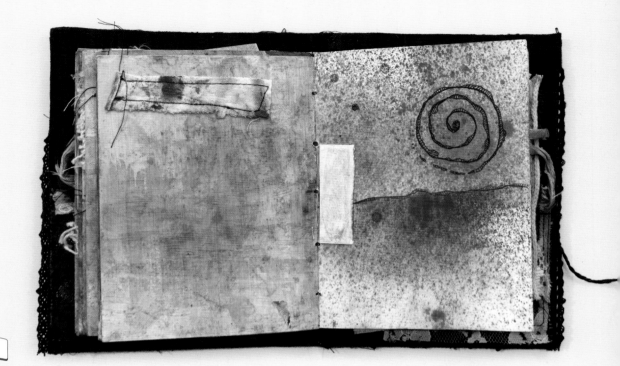

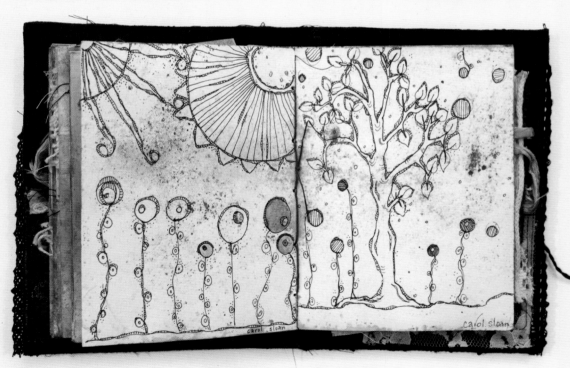

Circles sketchbook pages by Carol Sloan

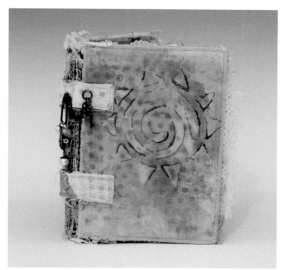

Cover of Circles art book

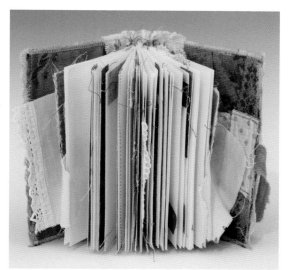

Fanned pages of Circles art book

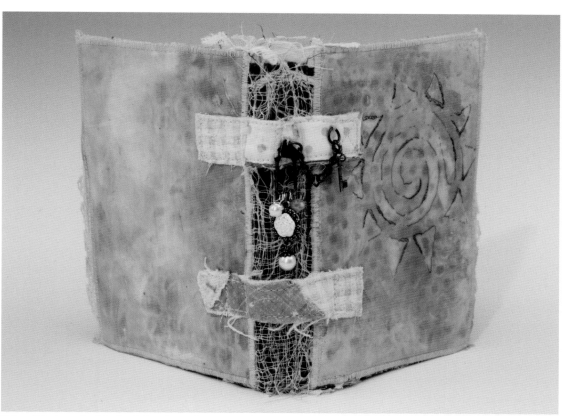

Spine of Circles art book by Carol Sloan (6" x 4" [15 cm x 10 cm]), inspired by her sketchbook pages (opposite page)

Artist: **LYRIC KINARD**

Lyric Kinard has a serious addiction to fabric. Much of her work begins with plain white cloth, which she dyes and paints to create the palette from which her designs spring. Lyric's designs emphasize the dimensional and tactile quality of quilts as a medium for expression.

Techniques Used: SCREEN PRINTING, FOILING, COLORED PENCIL, FREE MOTION

My sketchbook is a place where ideas come into being, time is filled, the brain is allowed to wander freely without expectations or limits. Compositions are explored and themes are developed when I need to get down to concrete work, but mostly it is a place to play.

For the theme of Circles, sometimes I traced any circular object that I could find, overlapping, and intersecting, and varying the size and scale of each sphere. Sometimes I went to the meditative place inside myself and methodically filled each space with patterns and textures. Sometimes I played with color and shade.

Often my artwork is inspired by the materials I use. I begin with a stack of fabric and audition combinations of textures and color until something pleases me or begins to speak to the direction I think the work might take. In this case I had a small collection of breathtakingly beautiful shibori-dyed scraps I had purchased from another artist. (Shibori is a Japanese method for dyeing cloth by stitching or compressing it by twisting, scrunching, or folding

it before it's dipped in a dye bath.) The patterns reminded me of my doodles, and I knew then that I would work with pattern and texture in cloth to reflect the patterned doodles in my sketchbook.

I collected possible color and texture combinations that worked with these scraps, then began to create more of my own cloth. I turned my doodles into patterns I silk-screened on my cloth. I used dishwashing detergent to remove some of the dye from my cloth. Cascade dishwashing gel has enough bleach in it to discharge (remove) the dye from fabric. Simply apply it to the fabric with a brush, stamp, or even through a silk screen and then rinse the fabric out once enough color has been removed. I then added some of the same screened patterns that I removed with the dishwashing detergent back into the cloth with foil adhesive.

Once my cloth was filled with dots and circles and color and pattern, I searched again for templates—no plate, dish, or vase was safe. The patterns were traced, the cloth was fused to Wonder-Under, a heat-activated adhesive, then cut out in

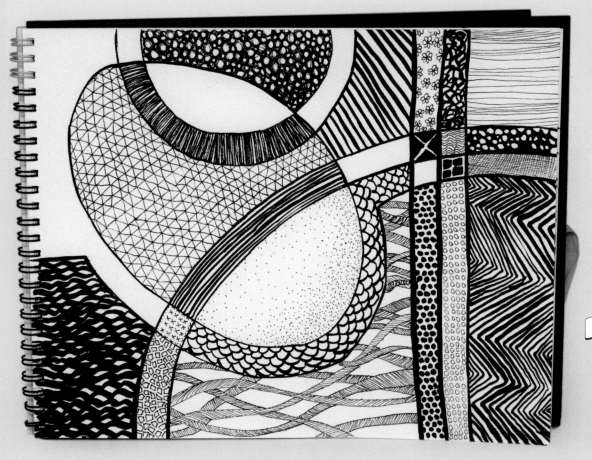

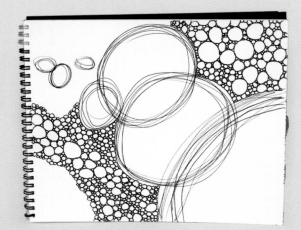

Circles sketchbook pages by Lyric Kinard

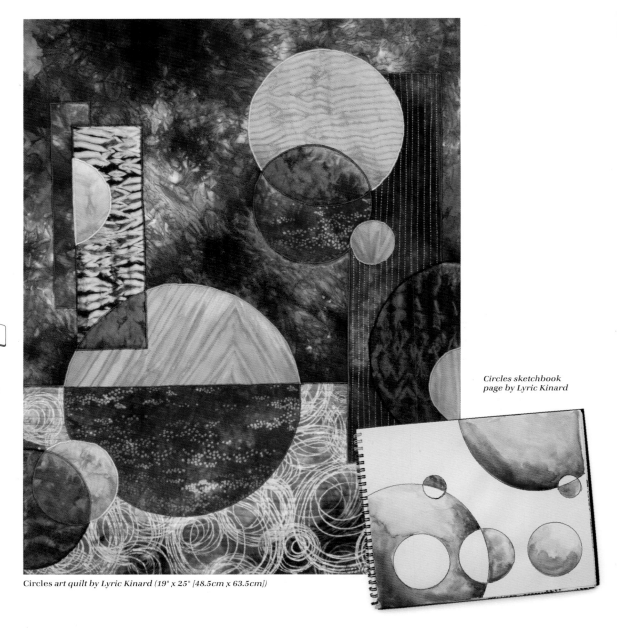

Circles sketchbook page by Lyric Kinard

Circles art quilt by Lyric Kinard (19" x 25" [48.5cm x 63.5cm])

various-sized circles and shapes. I didn't choose to follow a preset plan but worked directly on a design wall with the fabric, moving things around, trying out different colors and patterns, until a pleasing and balanced composition emerged. Once things were in place they were fused with the heat-activated adhesive onto one cloth, then I layered the resulting cloth onto a batting and backing and added stitching (page 67). The extra-dimensional depth of the quilted lines adds a wonderful layer of texture and line to the final composition—one of my favorite things about textiles as a medium.

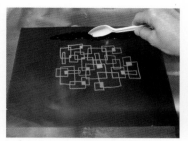

Place the silk screen on the fabric and pour some paint across the top edge.

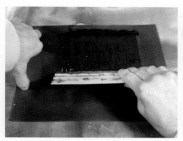

Pull the paint across the screen.

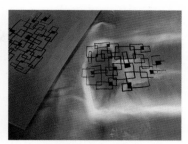

The printed fabric

Screen printing is one of the most versatile techniques there is for adding imagery and color to cloth or paper. Ready-to-use silk screens are widely available, as are services that will make a custom one for you using your own design, which you can find in the Resources section (page 143). You can also easily make your own using an image from your sketchbook and special sheets from EZ Screen Print called PhotoEZ. These sheets are treated with a light-sensitive water-soluble polymer that requires only a few minutes of sunlight and a short soak in tap water to develop, making it fast and easy for you to create a silk screen of an image from your sketchbook. Photograph or scan your sketchbook image, print it with an ink-jet or laser printer, and follow the instructions on the PhotoEZ website (http://ezscreenprint.com) to create your screenprint.

Using a Silk Screen

You will need a paint with some body to use with your silk screen; thin paint will be difficult to work with and may seep under the screen, muddying your design. Remember to use a washable textile paint if you are silk screening on a piece of fabric that will be laundered so that your design won't fade.

Working on a lightly padded work surface, pin or tape your fabric in place to keep it from shifting while you are silk screening it. Place your silk screen on top of your fabric and squeeze or pour a bead of paint across the top edge.

Hold the screen in place with one hand, and use a squeegee (or an old credit card if your design is small) to pull the paint across the screen with the other.

Carefully lift off the screen to reveal your design.

Screen Printing Tips

It takes practice to get familiar with how much paint and pressure to use when screen printing, so before you work on your project make some test prints on scrap fabric first.

Never let the paint dry on your screen or it will clog it. Always rinse your screens off as soon as you are done printing with them.

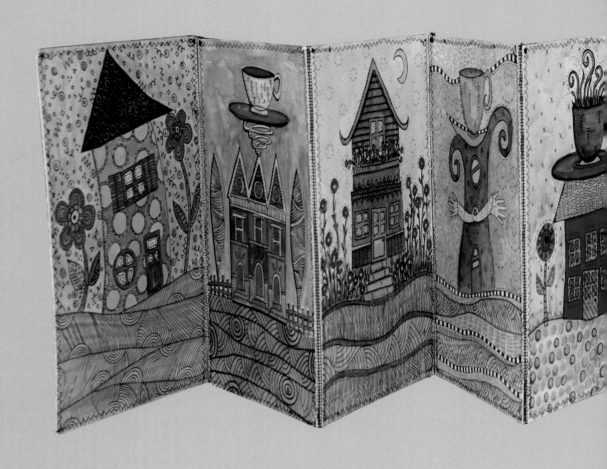

DWELLINGS

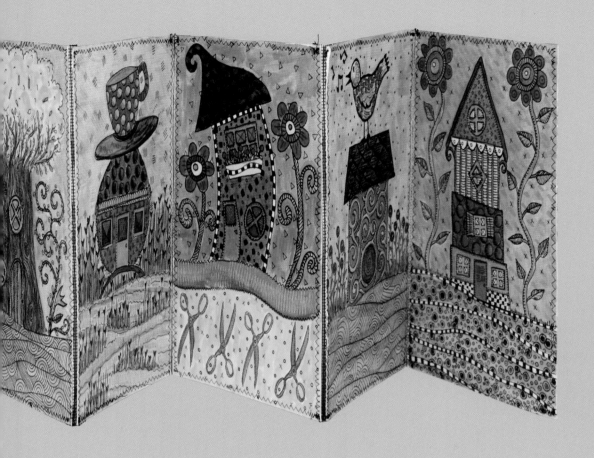

The first thing that comes to mind when you think of a dwelling is the house you live in, but stop a minute and think about some other types of dwellings: birds live in a nest, chipmunks in a hollowed-out tree, and bees in a hive. What about the dreams that dwell in your heart or the inventions that dwell in your imagination?

Artist: **JAMIE FINGAL**

Jamie Fingal is a mixed-media artist whose main medium is contemporary quilts, which have been juried into international quilt exhibitions and featured in many books. Her love of vibrant colors and whimsical, abstract style comes through loud and clear in her work.

Techniques Used: LINE DRAWING, WATERCOLOR, STENCILING, RUBBER STAMPING, COLLAGE

I already have a passion for making quilts with house designs, so drawing and painting on watercolor paper just seemed like another approach to explore this theme. I sketched out the possible construction for my Dwellings accordion book. Trying to figure out the size and how many paintings I would need was the real issue. I have found in working on projects such as these that it is best to design more than you need, because you draw deeper into your imagination with each piece.

I sketched out each house with pencil, one per panel, then painted each one with watercolor paint. After the paint dried, I outlined and drew in details with a black Micron pen. I found it interesting that some of the designs I used were the same designs I use in free-motion machine quilting.

The accordion book is made with watercolor paper, fused fabrics, and a household screen. I used my sewing machine to free-motion zigzag them together. The screen between the pages acts as a flexible section that allows each panel to bend and fold, forward and backward. Then I made a three-dimensional house out of fabric with a zipper on the side (page 44, bottom) that the Design House book fits into. It can stand up by itself with the book inside. A fun little design element.

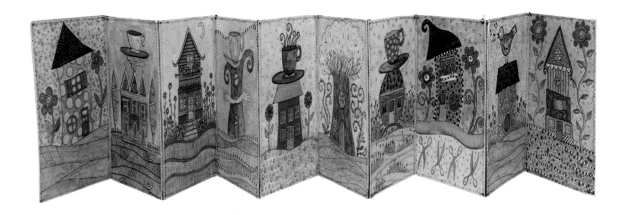

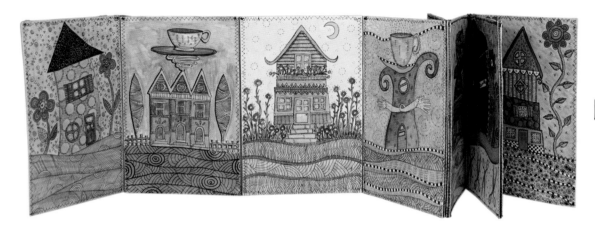

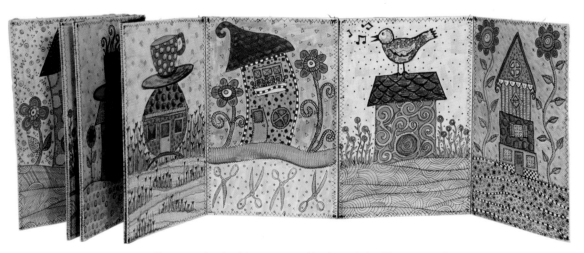

Dwellings accordion book by Jamie Fingal (each panel 6" x 9" [15cm x 23cm])

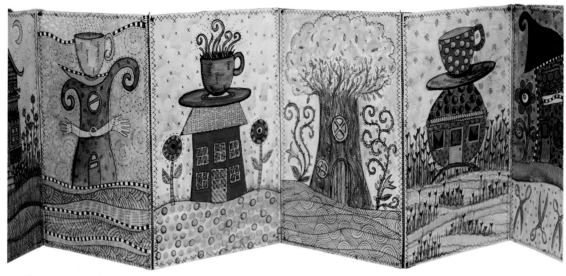

Dwellings center panels by Jamie Fingal (each panel 6" x 9" [15cm x 23cm])

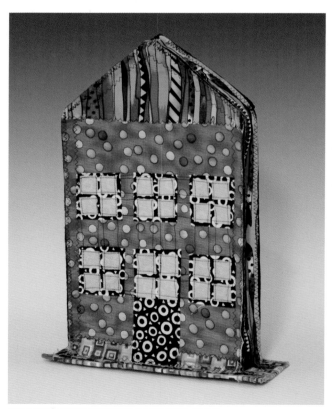

3D House by Jamie Fingal (12" x 7" [30.5cm x 18cm])

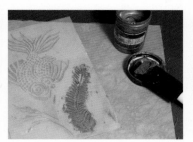

Place the stencil on your fabric.

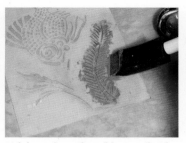

Lightly tap the surface of the stencil with the brush.

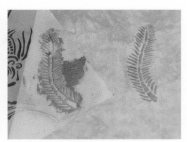

Lift the stencil off carefully so that you don't smear the paint underneath.

A stencil is a thin but strong piece of material (heavy paper, plastic, etc.) with openings in it that allow paint to pass through to the surface below, and it's a quick and easy way to add imagery to paper or fabric. Jamie used a stencil to add the dots in the lawn that the red house sits on in one of her house panels and then outlined some of the dots with blank ink to make them stand out a bit more (opposite page, bottom). You can easily create your own stencils from your sketches and doodles by tracing them onto a piece of clear plastic and then using a sharp knife to cut them out.

Place your stencil on your paper or fabric.

Put a small amount of paint on the brush and then dab off a little on a piece of paper towel or paper. Lightly tap the surface of the stencil with the brush. You don't want to tap too hard or you'll end up with paint seeping under the stencil.

Tip

You can buy stencil brushes but a foam brush will work just fine in most cases. Experiment to see which type of brush you prefer working with.

As soon as you are done applying the paint, carefully lift the stencil off the paper or fabric.

Stenciling Tips

Too much paint on your brush will cause puddling and the paint will seep under the stencil.

Don't work directly on top of plastic; paint will seep back up through the fabric and muddy your design.

Place a scrap piece of fabric or paper between your working fabric and a piece of plastic to protect your worktable.

If you're using the same stencil over and over again in the same work session, wiping it clean between uses will help keep the edges of the design free of paint. This makes it easier to get a nice crisp line and avoid blotchy edges.

Don't be afraid to use more than one color at a time when you stencil.

If you find that your stencil keeps shifting, use a bit of low-tack tape to hold it in place.

Artist: **DIANA TROUT**

Diana Trout is a painter, book artist, and teacher. Her sketchbook pages are bursting with color and imagery, and houses make a frequent appearance in her work. She loves to sit with a pile of papers—bought, found, and her own painted ones—in front of her sewing machine, stitching them together to form larger pieces to use in her work.

Techniques Used: **WATERCOLOR, PEN & PENCIL, CRAYON, STITCHING**

I've been working with house imagery for some years now in my NorthEast Kingdom series. I like to imagine which of my citizens would live in each little house. What do they think and feel? Is it an elderly couple, a bird family? An eccentric artist? In my mind, I populate the house as I am working on it. What are the furnishings like? I imagine many woven fabrics and tattered and beautifully patched textiles. There are deep chairs and a teapot always on the go. Sometimes, there is a sadness in the house and I'm willing to investigate that as well. I really see these little houses as vessels, vessels that hold people.

When working on a new body of artwork, my process is to work in a journal and on any paper that is handy. Sometimes, I'll want to try out different media or work on sketches in a larger format and so will choose a paper accordingly: watercolor, stitched and built paper, found papers, charcoal, fabric. My usual sketching tools are watercolor, pen, pencil, gesso, Caran d'Ache water-soluble crayons, and stitch. Mostly, I sketch at first to work out compositions and to remind myself to play with new colors. This is not a linear process for me. I start off with a few compositional sketches and then move to preparing my paper bases. Then I may take a couple of hours to sketch again, perhaps exploring color, and then go back to the artwork. I'm moving back and forth continually while building the final artworks.

One of my goals is pushing further with "building" paper (my word for patching and layering smaller pieces of paper into a larger one). So, that was the most important technique in creating the piece *Moon in Day* (opposite, bottom left); gluing, weaving, stitching, patching, piecing, and then repeating the process. When I began experimentations with building paper foundations, there were things that just didn't work. Failed attempts get put back into the mix and are simply part of learning.

I'm constantly learning about my process. I believe that your own personal process is revealed as you work over the years and it varies hugely from person to person. So it is best to not impose a system upon yourself. It is valuable to understand and honor your process to facilitate a free flow. Working along organically and always doing the next thing that occurs to me is the keystone of my process.

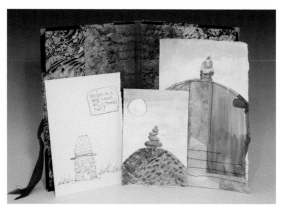

Dwellings sketchbook portfolio and pages by Diana Trout

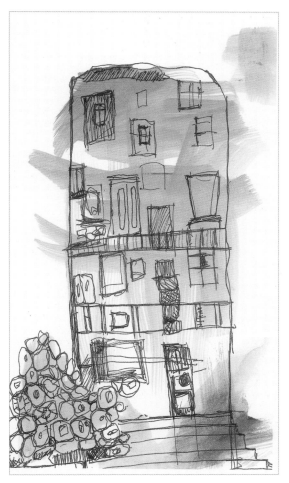

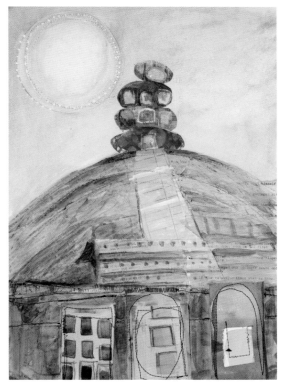

Moon in Day by Diana Trout (11" x 15" [28cm x 38cm])

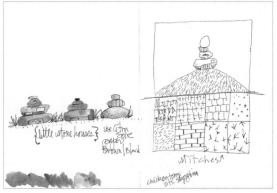

Dwellings sketchbook pages by Diana Trout (above and top)

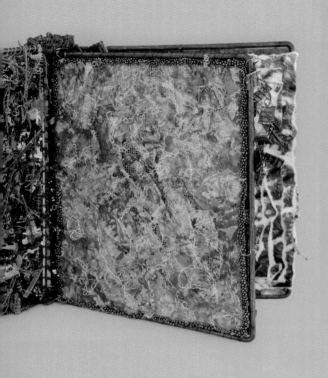

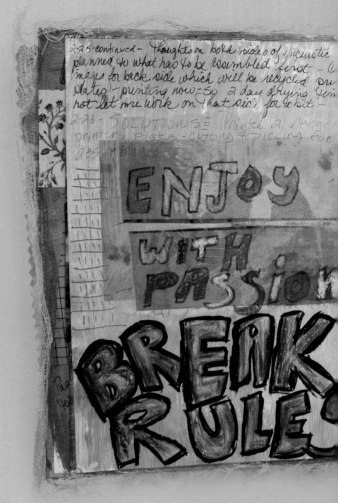

ELEMENTS

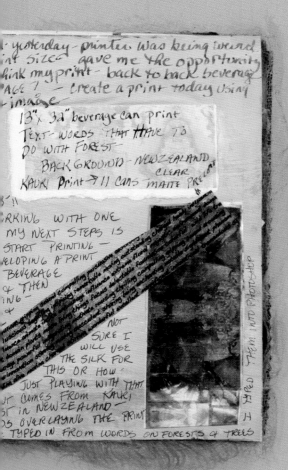

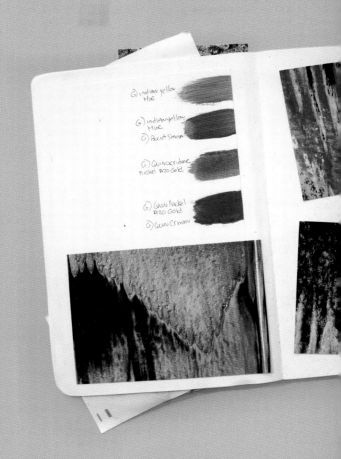

The word *elements* evokes a connection to nature and the world we live in. The elements of nature and their impact on our surroundings can sometimes be destructive. Aged, rusted, and weathered surfaces exposed to the elements of nature can provide the artist with a lifetime of exploration.

Artist: **KATHYANNE WHITE**

Kathyanne White's fiber art has been exhibited in museums and galleries throughout the United States and abroad. Most recently she has been teaching workshops focused on expanding the digital print to uncommon surfaces. She inspires students to create quality digital prints on alternative surfaces for their artwork.

Techniques Used: **DIGITAL PRINTING, FABRIC PAINTING, ENCAUSTIC PAINTING, LUTRADUR**

Elements is one of my favorite terms since my work has a digital element with which I build intriguing textural surfaces.

My work with sketchbooks can run hot and cold. With this project I saw working in the sketchbook as an opportunity to develop a visual-artist statement to show along with the artwork so people observing the work can understand the digital process that helped develop the ideas in my assemblages.

First I built a sketchbook I wanted to work in. I chose an old book, painted the pages randomly, and added a multipage journal-like cover around the original book. These outside pages gave me a place to play while pondering construction ideas. That left the inside of the actual book to work out my art piece. This always feels better to me than a notebook with plain white pages.

I had already decided to create a piece in conjunction with my new Forest Book series—which explores and expands digital printing on alternative surfaces—but in a smaller form, a study for the series (page 52). In my Forest Books I build a forest environment using digital prints on surfaces created from recycled materials, uncommon fiber, and hand construction. These digitally printed surfaces are combined and assembled to create a rich and lush environment for books up to six feet tall. The book pages explode with textures and imagery.

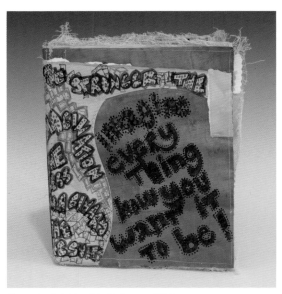

Elements sketchbook by Kathyanne White

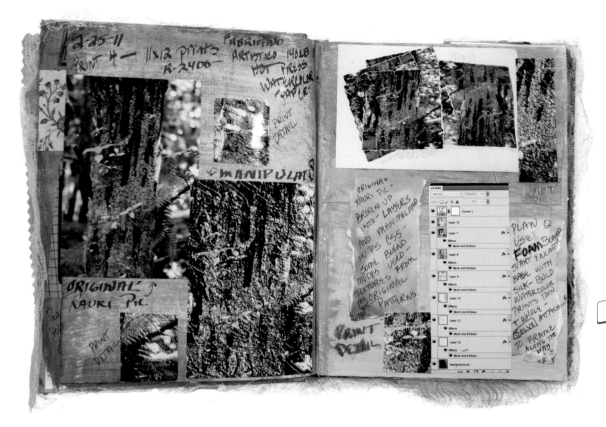

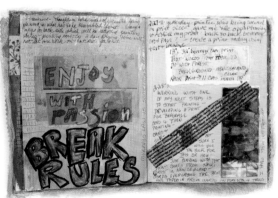

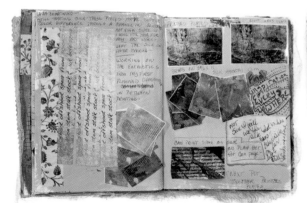

Elements sketchbook pages by Kathyanne White

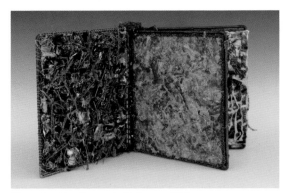

Elements art book pages by Kathyanne White

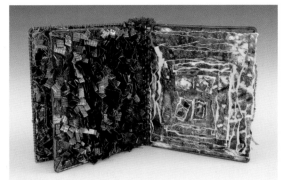

More pages from Elements art book by Kathyanne White

Once the artwork was planned, I used the sketchbook to chart what I was doing. When I was creating, I took pictures to document the process. Although the basic ideas were written on the beginning pages of the sketchbook, things evolved more off the sketchbook than on.

I am a very hands-on creator, so once my digitals are printed, experimenting with the assemblage is more important to me than the sketchbook. This challenge was wonderful for moving me to use the sketchbook to plan and also document the journey my artwork is taking. I stopped doing studio journals a couple of years ago and so much of my process exists in my head. But then what happens to untried ideas for a piece? Many ideas and thoughts go into my work, and getting into the discipline of a sketchbook to accompany each piece had been missing lately.

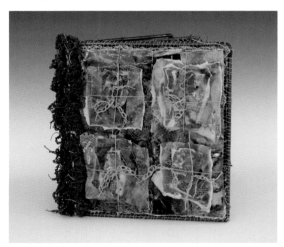

Elements art book by Kathyanne White (11" x 12½" [28cm x 32cm])

In 2009 I figured out how to digitally print on recycled beverage cans. That was the year that I received an Artist Project Grant from the Arizona Commission on the Arts to expand the digital print to uncommon surfaces. If I had been keeping a sketchbook at the time, I would have a record of where, when, and how the idea of printing on recycle beverage cans came about.

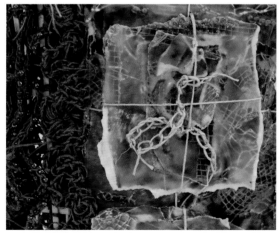

Cover detail, Elements art book

A selection of surface precoats

Coat the Lutradur with a precoat and let it dry thoroughly. I'm using Ink Aid Iridescent Bronze Gloss precoat.

Photos printed on the bronze-coated Lutradur

Essentially any surface that you can feed through your ink-jet printer can be used as a surface for printing on, and each will produce different results depending on the type of surface and how you prepare it. It's important to first treat the surface you want to print on with a precoat or ground so that the ink from the printer can bond with the surface.

There are several companies that manufacture precoats or grounds to prepare surfaces for ink-jet printing, so experiment to find the ones that you prefer working with to get the results you want.

Lutradur is a nonwoven polyester surface that feels like a cross between paper and fabric, and it makes a wonderful surface for digital printing. To prepare it, coat the surface with your chosen precoat using a foam brush and let it dry thoroughly.

You may need to use a carrier sheet—a piece of paper that you attach the Lutradur to so it will feed through the printer correctly. Experiment to find the best type to use for your printer. You can iron the Lutradur to the shiny side of freezer paper or use double-stick tape to attach it to a piece of printer paper. Cut your piece of coated Lutradur to the size that your printer will accommodate, attach it to your carrier sheet, and you are ready to print on it.

Tips for Working with Photographs

Read your camera manual! It's tempting to just pop the battery in and start taking photos but taking the time to read through the manual will help you learn about all the features your camera has to offer. Also check the manufacturer's website. Most offer more documentation as well as forums with helpful tips.

Take your photos in the highest resolution setting possible. This will give you more options later should you want to manipulate them using photo editing software.

Get close to your subject, either physically or by using the zoom. Getting closer to the subject allows you to capture the surface texture.

Don't try to cram too much into one photo. Identify the element you want and focus on getting a shot of that. If the barn in the field interests you, then fill the frame with as much of it as you can rather than taking a photo that's mostly field with a small barn in the center.

Look at the details. The shape of the old rusted gate or wooden fence might not appeal to you, but the texture and colors of the surfaces might.

Don't just focus on the big picture. Take a wide shot of the field of wildflowers to capture the color variations and then get in close and take details.

Artist: **SUE BLEIWEISS**

A lot of my work revolves around exploring how to create texture both real and implied on a piece of fabric using dyes, paints, and stitching. The colors and textures in rusty and weathered surfaces fascinate me and I often use these as inspiration when I begin a new piece of work.

 Techniques Used: **PHOTOGRAPHY, FABRIC PAINTING**

I am inspired by the textures and colors of surfaces left exposed to nature and the weather, so this theme presented many possibilities for me. It was an easy one to work with and one that I will continue to explore for a long time. Rather than working with pen, pencil, or paint, for this theme I turned to my camera. Using my point-and-shoot I went in search of surfaces that had been aged from the exposure to the elements of nature.

Back in the studio I printed my pictures on good-quality photo paper using the highest-quality settings and started the process of translating the colors in the photo onto paper using paints and inks. This step forces me to spend some time really looking at the color variations in the surfaces. At first glance it may appear that the surface in the photo is made up of just two or three colors, but taking the time to really study it reveals a lot more shades and color variations. Identifying these subtle differences will make for a much more intriguing surface when I use this information to move off the sketchbook page and onto my working surface.

I decided to work with my photographs of old copper surfaces as the inspiration for this project. I painted some silk fabric using the information from the color card I created and then hung it up in my studio so that I could see it while I thought about what I might like to create with it. Rather than just cutting into it without any plan at all, I went back to my sketchbook to sort through some ideas and kept coming back to wanting to create a vessel. I didn't spend a lot of time making perfectly rendered drawings of what I wanted to create because these rough sketches are only meant to act as a guide. I make notes about shapes, sizes, and the emotion I want to convey or the story (if there is one) that I want to tell with the artwork. Laying the foundation this way allows me to create with intention and forethought and I enjoy the experience more. Serendipity is great and will always have a place in my studio, but you can't rely on it to get you where you want to go.

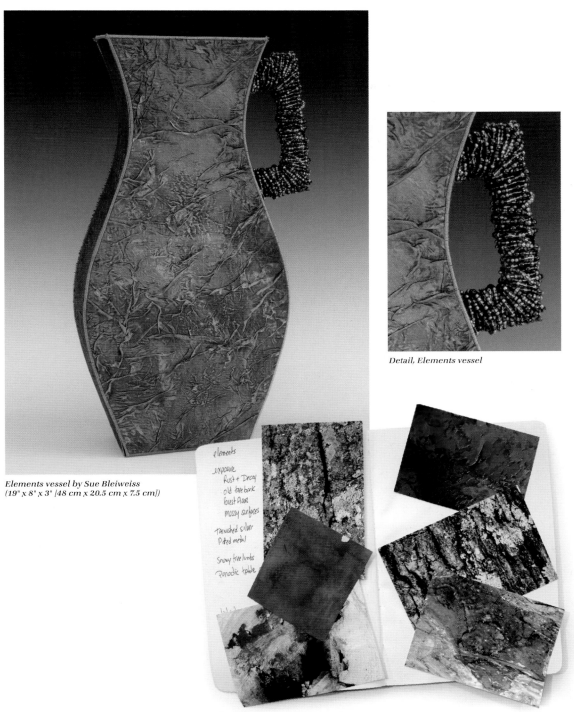

Elements vessel by Sue Bleiweiss
(19" x 8" x 3" [48 cm x 20.5 cm x 7.5 cm])

Detail, Elements vessel

elements

exposure
 Rust + Decay
 old tree bark
 forest floor
 mossy surfaces

Tarnished silver
Pitted metal

Snowy tree limbs
Periodic table

Elements sketchbook by Sue Bleiweiss

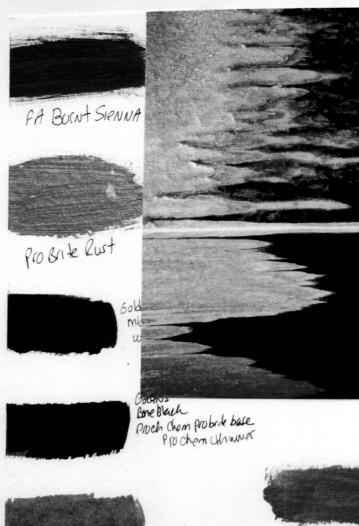

FA BURNT SIENNA

Pro Brite Rust

Gold
mi
w

Goldens
Bone Black
Pro Chem Pro brite base
Pro Chem thinner

Goldens turquoise w probrite base /water

Lumiere
metallic copper

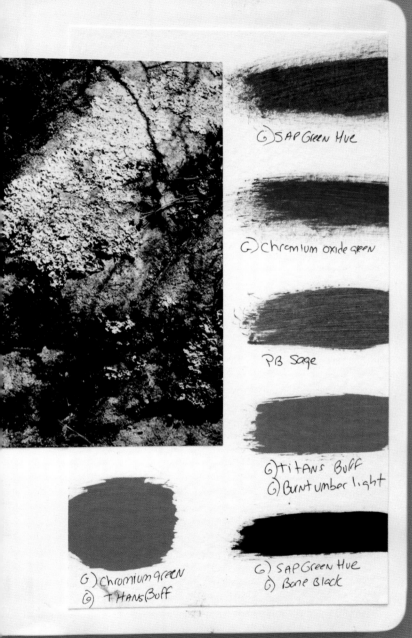

G) SAP Green Hue

G) Chromium oxide green

PB Sage

G) titANs Buff
G) Burnt umber light

G) Chromium green
G) tHANsBuff

G) SAP Green Hue
G) Bone Black

Elements sketchbook by Sue Bleiweiss

20 21 22 23 24 25 26
27 28

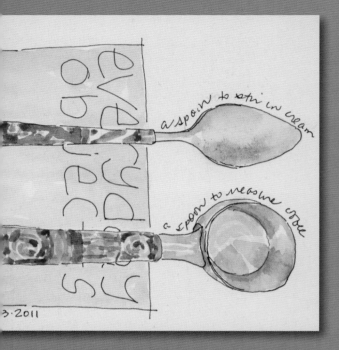

everyday objects

everyday objects

a spoon to stir in cream

a spoon to measure coffee

3·2011

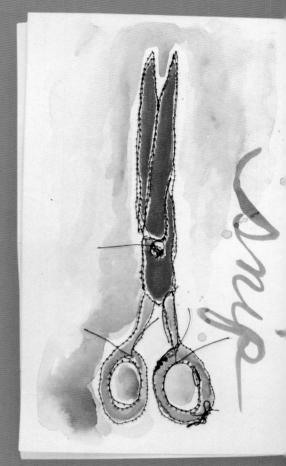

snip

EVERYDAY
OBJECTS

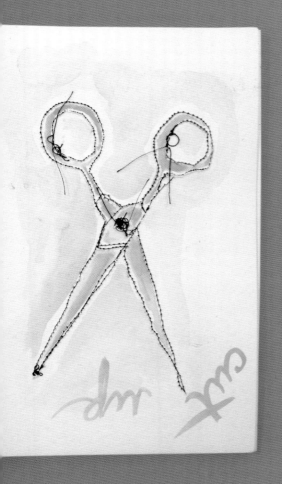

Sometimes a theme as generic as Everyday Objects can be overwhelming. There are so many everyday objects, it may be hard to know where to start. If this happens to you, try breaking down the theme into smaller segments. For instance, the everyday objects in your purse, pocket, bathroom cabinet, or kitchen utensil drawer. What's in your refrigerator or freezer or even the glove compartment of your car?

Artist: **JANE LAFAZIO**

A mixed-media-artist working in paper and cloth, Jane is inspired by the symbols within traditional folk arts as well as the icons of Mexico and Asia. She loves the thrill of discovering a new art technique, unusual color scheme, or fabulous piece of fabric.

Techniques Used: **WATERCOLOR, PEN & INK, DIGITAL PRINTING, THREAD SKETCHING**

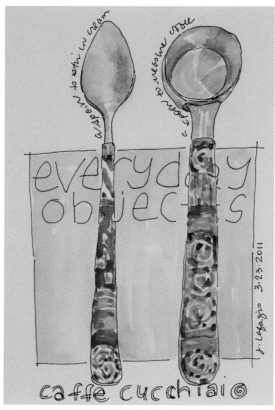

Watercolor sketches by Jane LaFazio (above and opposite page)

I love the theme of Everyday Objects. I often draw in my journal at home, so I had all the subject matter on hand. I could have kept up with this series for a long time! I'm looking at everything in my house differently now, and with new appreciation of the things I use on a daily basis.

After I'd done about five pages, I started thinking about where I'd go next. I knew I wanted the piece to be sewn, so I started imagining ways to transfer the images to cloth. I decided to free-motion stitch the images on a machine using black thread to mimic the pen lines in my original drawings. I had been collecting old linens and thought they would be a good match with my household item theme.

I scanned my images and printed them onto deli wrap (butcher paper). I pinned the deli wrap on the back of the quilt (fabric and batting) and machine stitched the drawing from the back. Then I turned the quilt over and stitched again to get that hand-drawn line.

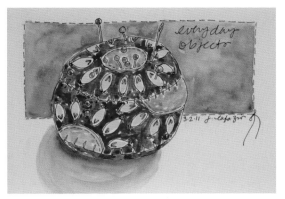

everyday
objecto

3·2·11 J. lafazio

everyday objects
la sueglia

J. lafazio
3·18·2011

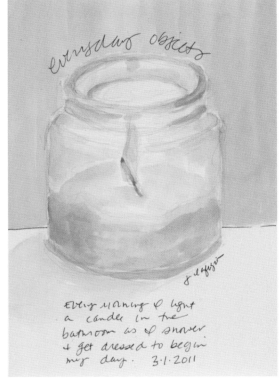

everyday objects

J. lafazio

Every morning I light
a candle in the
bathroom as I shower
+ get dressed to begin
my day. 3·1·2011

I use a method that seems to work for me, which is creating one piece at a time, without a plan for the final composition. I created pieces as I did a new drawing. I added paper to some, using a scrap of something that was meaningful to the drawing, like the bit of dress pattern for the pincushion and the calendar page for the clock.

Once I had the pieces, I began to arrange them in a pleasing composition. I then hand stitched each piece to a large piece of wool felt, adding additional hand stitching as I went. I really enjoyed working with such personal items, each of which carries special meaning for me.

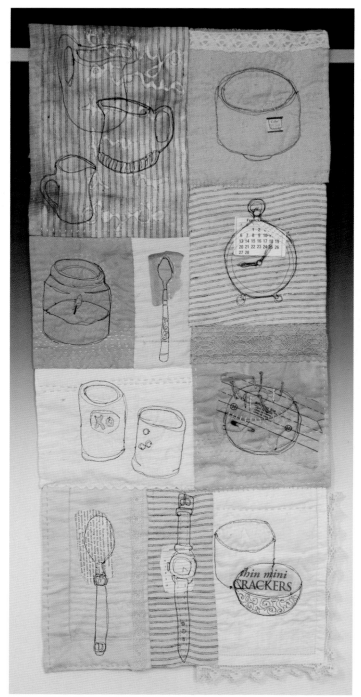

Details, Everyday Objects Tell My Story
(top, above, and opposite page)

Everyday Objects Tell My Story *art quilt by Jane LaFazio*
(34" x 15½" [86 cm x 39 cm])

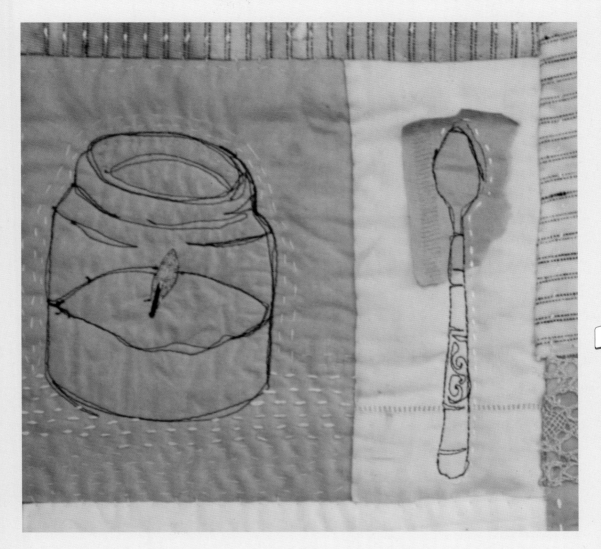

Artist: **KELLI NINA PERKINS**

A librarian and mixed-media artist, Kelli Nina Perkins has been making art that prizes the everyday ephemera of our lives. She often mixes paper with the dimensional qualities of cloth and creates collaged quilts embellished with painting, stitching, needle felting, and beading.

Techniques Used: **THREAD SKETCHING ON PAPER & FABRIC, DIGITAL PRINTING**

We are surrounded by small tokens of our nature that say so much about our daily lives. We eat, we love, we mend, we dance, we come together, and we part seamlessly. I've been fascinated by kitchen utensils like spoons and sewing paraphernalia like spools of thread. Imagining my everyday objects brings a smile.

Physical items in space have a distinct presence. For this project I first studied scissors and also images of scissors. I decided to draw a series of four views with simple lines and then collage them with text ripped from book pages. I loved the clean, bare lines of the scissors, so I finished them with free-motion-machine thread sketching (page 67) in black. A series of any everyday object is likely to be somewhat consistent thematically, so I used different perspectives and orientations to add some variety. Since I often scan my sketches and use them in a number of ways, keeping my sketchbook images clean and neutral allows me the most versatility. I find that even the smallest sketch can play a central role if scanned and printed for mixed media. A sketchbook is a useful tool for practice, but that doesn't mean

some of your favorite images can't come out into the light of day!

My original concept was to create one pillow with four images of a pair of scissors. But once I began playing with colors, I saw so many combinations that a single set of images wasn't enough. That's when I decided to give each image its due with a separate mini pillow that could be embellished to my heart's content (page 66).

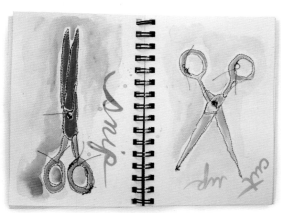

Sketchbook page (above and opposite page) by Kelli Nina Perkins

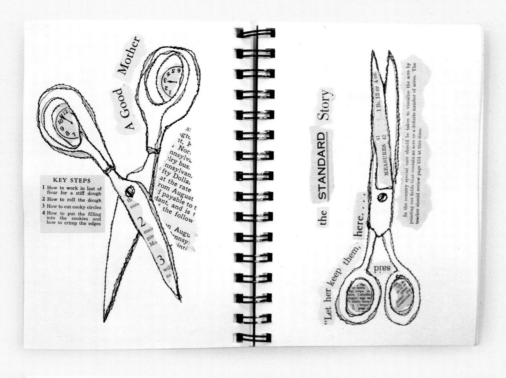

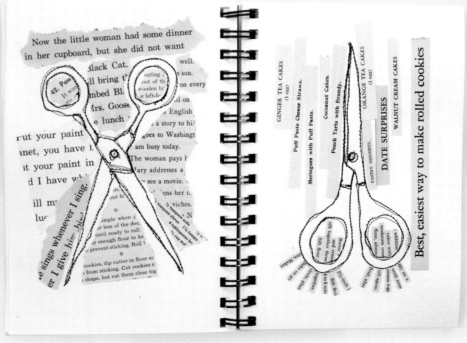

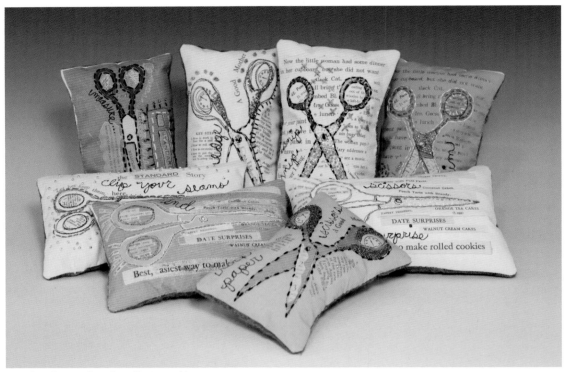

Everyday Objects pillows by Kelli Nina Perkins

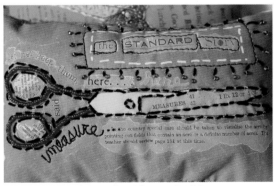

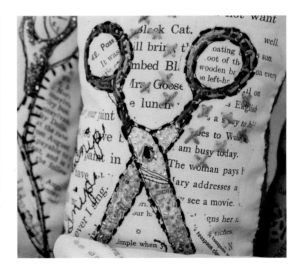

Detail, Everyday Objects pillow (above and right)

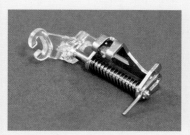
An open toe foot

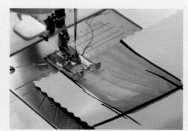
Place your paper under the needle and begin stitching.

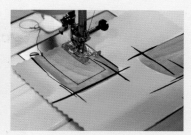
Take your time when stitching on paper.

Adding stitching to your sketchbook pages or fabric is easier than you think. You can either free-motion stitch using an open toe presser foot on your sewing machine (consult your sewing machine manual for directions on how to use this foot) or use your standard sewing machine foot.

When you thread sketch on paper you need to be mindful of not stitching too heavily in one place or your paper may tear. The goal with thread sketching is to enhance the design, not to completely cover it with stitching.

Set up your sewing machine for free-motion stitching. On most sewing machines this means lowering the feed dogs to allow your paper or fabric to move freely while sewing. (Consult your sewing machine manual for instructions for your particular machine.) Place your painted sketchbook page under the needle where you want to begin stitching, lower the pressure foot, and start sewing.

If you are using your open toe foot, keep in mind that the length of your stitches is determined by how fast or slow the machine is running and how fast or slow you move the paper or fabric. There's no need to run the machine at top speed. Take your time and remember to breathe!

Thread Sketching Tips

Use a heavyweight or watercolor paper for thread sketching and don't try to thread sketch on a piece of paper that is wet with paint or glue.

Using a longer stitch length than you normally would will help keep the paper from being perforated or torn when handled.

Use a sharp needle when stitching on paper; a dull needle will make a bigger hole than you want and may actually tear the paper instead of piercing it.

Remember that once you sew into the paper, you can't rip your stitches out without leaving holes! Do some practice sewing on a piece of scrap paper first before stitching on your final project.

If you want to sketch an image from your sketchbook onto fabric, trace it onto some tissue paper first, place the tissue paper on the back side of your fabric, and then thread sketch over the tissue. Since the tissue is on the back side of the work and won't be seen, you can leave it or, if you prefer, gently tear it off.

When thread sketching on fabric, you might find it helpful to stretch the fabric in an embroidery hoop to keep it from bunching as you stitch or fuse it to a piece of interfacing to give it some extra body.

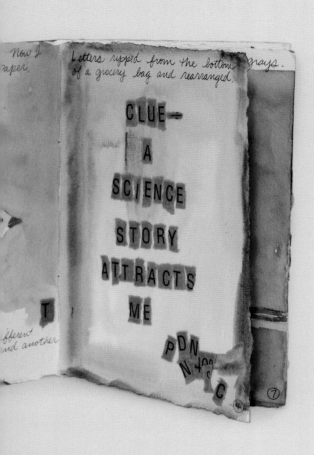

Now I
...aper.

Letters ripped from the bottomnays.
of a grocery bag and rearranged.

CLUE →
A
SCIENCE
STORY
ATTRACTS
ME

T
...ferent
...nd another

PDN...
N...
C

④
⑦

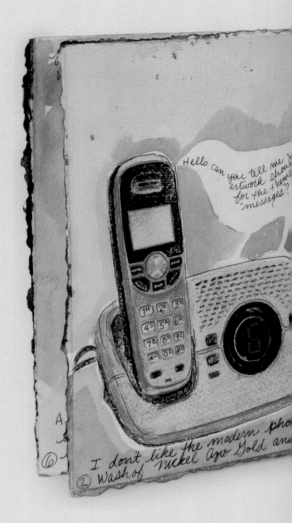

Hello can you tell me
...rtwork abou...
for the ...hou...
messages?

A
⑥
I don't like the modern pho...
② Wash of Nickel Ago Gold and

MESSAGES

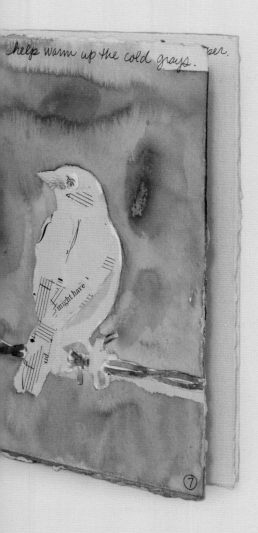

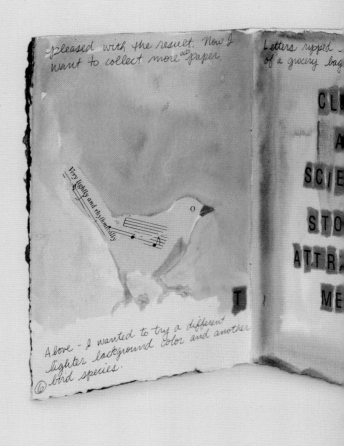

Every day we're bombarded with messages, from the advertisements on television and in newspapers and magazines to emails and texts from friends and family. Some are obvious, like the ones you see on the printed page, and others are subtler, such as a loved one reaching out a helping hand or a friend lending a sympathetic ear.

Artist: **KIM RAE NUGENT**

Kim Rae Nugent is a mixed-media artist who enjoys the creative challenge of working in various mediums. Nature is often portrayed in her artwork and birds are a favorite subject.

Techniques Used: COLLAGE, COLORED PENCIL, ASSEMBLAGE

This was a difficult theme for me as nothing visual came immediately to mind. After sitting with the theme for a while I decided the best way to approach it was to simply begin. I had some precut collage letters from magazines, so I started with them, spelling out the word *messages*. I hoped to develop a color theme from the letters and that they would influence a design.

On my second sketchbook page I drew a picture of my phone and colored it in with colored pencils, then let it sit for a day. The next day, the black and silver colors seemed cold and unwelcoming and I wasn't attracted to the modern look, so I painted a gold wash on the page, painting around the image of a bird. The bird is asking, "Can you tell me what my artwork should be for the theme *Messages*?" My third sketchbook page was inspired by the letter *E* in the collaged word *messages*. I liked the graphic boldness and colors of the letter. I also like to write down what I am thinking of my art as I create it.

After grocery shopping I stopped at the coffee shop to work on this challenge. Sometimes a new environment helps the creative process. I ripped apart the letters on the bottom of a paper bag, rearranging them until a message appeared. The remaining letters were later glued on other pages and in a pile at the bottom of the fourth sketchbook page.

I began the fifth page by tracing around an owl I had previously created. (I don't usually work my pages in the order that they appear in my journal; instead I jump around, repurposing art that I already have in my sketchbooks to save myself steps in the creative process.) I then painted a wash of phthalo blue and burnt umber around the owl. The owl was such a stark white in comparison to the background. A piece of old paper on my desk caught my eye, and I searched for more vintage collage papers in my stash. Some of them had text printed on them and if I incorporated them into the owl collage, these could form the "messages." Pleased with the owl, I wanted to explore this technique further trying different, lighter background colors and other bird species. These became my sixth and seventh pages.

For me, an art journal's primary purpose is to be a place to simply create without thought of it inspiring a finished piece of art (page 72). At times what

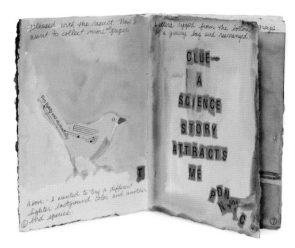

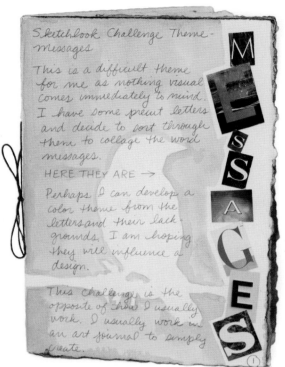

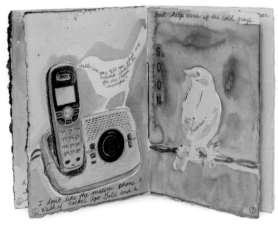

Messages sketchbook pages by Kim Rae Nugent

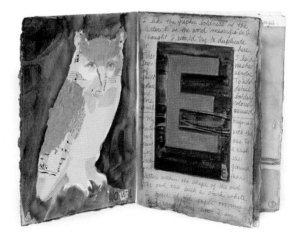

I have created in my journal has led to creating a finished project, it just isn't planned. In this case, it took awhile before I was able to attach anything visual to the theme, but I got past it by just working in the sketchbook. Taking a portion of the idea I liked on one page and further developing it on another page helped me proceed.

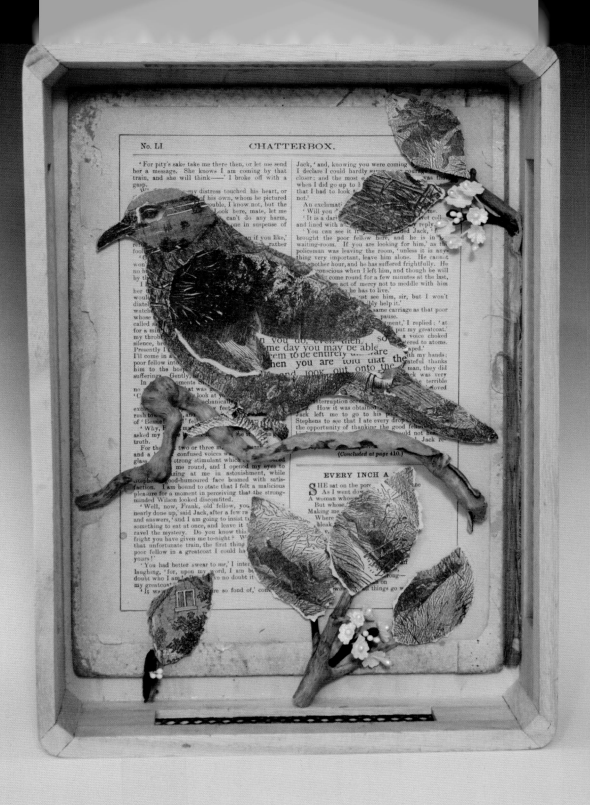

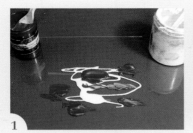

1

Drop some paint onto the glass.

2

Run a brayer across the surface.

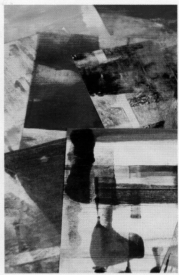

A selection of painted papers for collage

3

Peel back the paper carefully and set it aside somewhere to dry completely.

4

When I had gotten enough prints using the first color, I dropped some purple and some more white paint on the glass and lifted another print.

I like to keep a stash of painted papers on hand for collage work and this glass painting technique is my favorite way to make them. It results in papers that are rich with both color and texture and I frequently end up using them as whole sheets to make books and journals. Use any paper you have on hand for this technique: sketch, watercolor, drawing, un-waxed deli paper, etc. Consider using paper with text or images on it such as old maps or pages torn from old books or dictionaries.

Start by dropping some paint onto the surface of the glass and using a foam brush to spread the paint out a bit. Notice I haven't spread it over the entire surface of the glass. The paint is going to get moved around in the next step, so you don't have to completely cover the glass.

Place your paper over the paint. Run a brayer across the surface to make sure that the paper comes in contact with the paint. Roll the brayer from the center out. This pushes excess paint out to the edges, where it will get picked up on the brayer and deposited onto the back of the sheet as you roll back across it.

Depending on how much paint you dropped onto the surface to start, there's probably a good amount still left on the glass. Without adding any more paint to the surface, put another piece of paper onto the paint and repeat the process. When you've done enough pages and lifted just about all the color off the glass, move on to another color that complements the first, without bothering to clean off the glass.

OPPOSITE PAGE: *Messages assemblage by Kim Rae Nugent (9" x 12" [23 cm x 30 cm])*

Artist: **JUDI HURWITT**

Judi Hurwitt is a mixed-media artist whose work is a reflection not only of the contemporary world but also of her upbringing during the struggle for women's equality in the late sixties and seventies. She communicates her voice and views through the careful manipulation of texture, color, and materials in a vibrant but balanced design.

Techniques Used: **QUILL PEN AND INK, PAINT**

My initial impression of the theme Messages was of quiet, personal, and somewhat mysterious passages, possibly love letters hidden away in a drawer for decades or faded graffiti on a city wall. You want to get closer, read every word, and that was the feeling I wanted to evoke with this theme.

While the sketchbook version of this piece was dashed out quickly using the most basic tools in my arsenal, it was the emotion behind the work that informed the color choices and the somewhat desolate nature of the piece. I used a quill pen and ink and acrylic paint applied in several layers of washes. Basic paintbrushes were my primary tool.

The most challenging aspect of this piece was adequately expressing the meaning behind it. My father had recently been diagnosed with dementia and had to be moved from Pennsylvania, where he had lived his whole life, to Texas, to be near us so that we would be better able to care for him. His diagnosis has been devastating to our family, and this piece of art reflects some of my emotions surrounding it. Since this piece was done quickly in a fog of grief

and anger, the techniques were simple and plaintive and translated easily onto stretched canvas. I moved quickly and used a primed, stretched canvas I had previously prepared. For the underpainting, I scumbled on a very light layer of fluid acrylic paint in burnt umber. When that was dry, I inscribed with

"Dear Dad" canvas by Judi Hurwitt (8" x 10" [20.5cm x 25.5cm])

"Dear Dad" *sketchbook page by Judi Hurwitt*

a quill and sepia-colored India ink, a letter to my father using Stacked Journaling (a technique where words are first written in a shape and then additional text is written on top to obscure the writing below—several layers of this result in an image that looks like text, but can no longer be read). The final layers were simple alternating washes of thinned burnt umber and Mars black fluid acrylic paint.

PATTERNS AND GRIDS

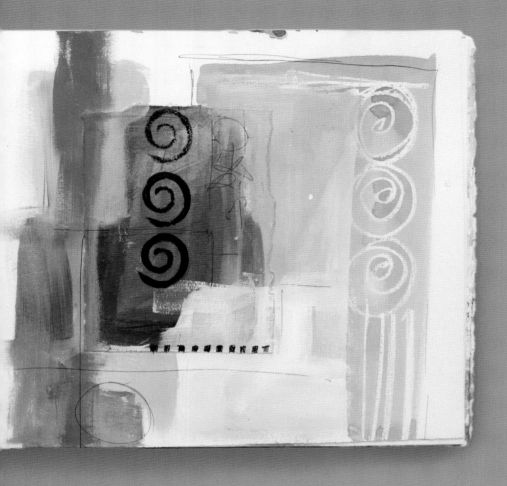

Patterns and grids are everywhere and, once you start look-ing, you'll notice them popping up all over the place. You might see them in grocery store aisles with all those neat rows of cereal boxes and jars of sauce, or perhaps it is the pattern sunlight makes on the ground as it streams between the leaves of a tree that catches your eye. Maybe it is even the way the pavers are laid in the brick walkway in front of your door.

Artist: **JANE DAVIES**

Jane Davies is a full-time artist working in collage, painting, mixed media, and encaustics. She offers workshops at her studio and nationwide, focusing on helping people find a personal and playful approach to creating.

Techniques Used: **COLLAGE, STENCILING, HAND-CARVED STAMPS**

Patterns and grids are my elements, which is why I chose to work on this theme. Pattern, in particular, is a thread that has run through much of my work; from the time I was a potter creating patterns on ceramic pieces, through designing fabrics, scrapbook papers, and other colorful manufactured products, to using the repeated motif in my collage-paintings, pattern has been one of my go-to modes of expression.

I often use the grid as a compositional starting point. Some of my pieces are more obviously grid-based than others when they are finished, but I seem to think visually in terms of grids. I consider it a fundamental organizing principle, and I use it as the basis for teaching the elements of composition before moving on to more free-form formats.

In my sketchbook I feel free to pose visual questions, to set up a problem to solve, and to throw myself deliberately off balance. Since this theme was familiar territory, I used the sketchbook to try new combinations of materials and colors that are not on my palette. I used my usual set of techniques: acrylic paint applied with various tools

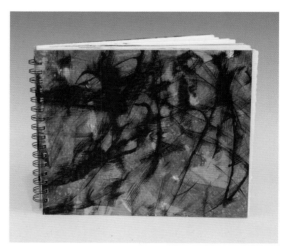

Patterns and Grids sketchbook by Jane Davies

such as my hands, found objects and brushes, and collage applied with matte medium. And I used some of my own "scribble-painted" papers, which incorporate lots of different paint application techniques, including printing with textures, scraping paint with a credit card, spritzing water and then blotting it, spattering, stamping, and many others.

I can rarely bring myself to work on a theme suggested by another person. However, since the

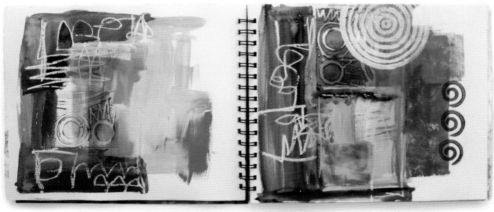

Patterns and Grids sketchbook pages by Jane Davies

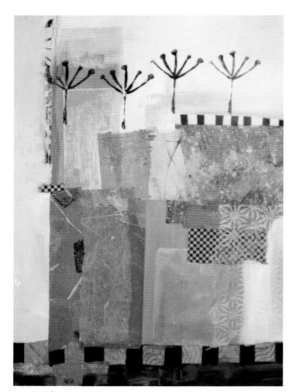

Untitled *by Jane Davies (11" x 15" [28cm x 38cm])*

sketchbook challenge began, I have gotten more comfortable with the process.

Scale is an important aspect of artwork. You can't take a small piece and enlarge it and have it be as successful at the new size. To translate my ideas from the sketchbook, I basically tried to use some of the same elements, but gave them more breathing room. I used the same materials and techniques, but allowed more resting space in the larger pieces.

Before the sketchbook challenge I used sketchbooks for almost everything but for working out ideas to any useful extent. I rarely pushed ideas beyond a verbal and linear description, and almost never painted or collaged in my sketchbooks. I have dozens and dozens of spiral-bound books filled with notes, lists, phone numbers, outline sketches, a few doodles, and reference material, but almost no paint or collage, and no working out of ideas visually beyond the pencil sketch.

Artists use sketchbooks in different ways, but for me the essential element is using it to develop ideas, try new things, experiment on safe ground, mess up, discover, and play. It is emphatically not a place for me to make pretty pages or finished compositions. The sketchbook challenge clarified my understanding of my own processes and has been pivotal to my now-established habit of working in a sketchbook.

OPPOSITE PAGE: Untitled *by Jane Davies (11" x 15" [28cm x 38cm])*

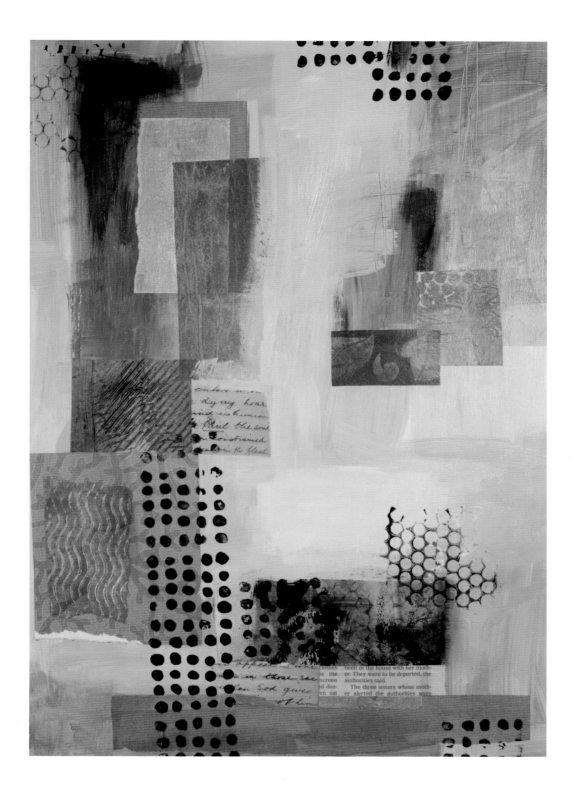

The advantage of carving your own stamps rather than using purchased ones is that it makes whatever you use them on unique and truly your own work of art. I like to carve on the Blick E-Z-Cut printing blocks from Dick Blick because their surface is soft and easy to carve. Rubber erasers are another option for carving stamps. They're small but they work well for simple designs. You can carve a whole set of coordinating stamps in no time at all.

Speedball cutters

I use the Speedball brand linoleum cutters. They feel good in my hand and are relatively inexpensive to start off with. Use care when handing these tools, though, because they are very sharp. Always be aware of where the hand that is not holding the tool is and always use a pushing motion and not a pulling motion when carving.

To create a stamp from an image in your sketchbook, trace the image onto a piece of paper using a pencil and then place the tracing with the pencil side against the carving block. Burnish it with the back of a spoon and then lift back the paper to reveal your design on the block.

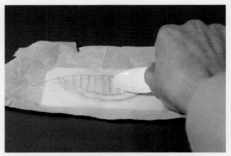

Place the tracing on the carving surface and burnish it with the back of a spoon.

Use the carving tools to cut around the design.

Leave some of the block surface beyond the edge of your design to create a more stable stamp. Just make sure that the extra block material is below the actual carved surface of the stamp so it won't be inked when it comes time to use your stamp.

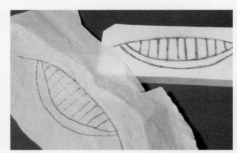

The design transferred to the carving surface

Ink up your stamp using a stamp pad or use a foam brush or a brayer to apply paint to your stamp and make a test print before using it on your project. A test print allows you to check to make sure that there is no excess stamp material that needs to be cut away and that you're not adding too much or too little paint to your stamp.

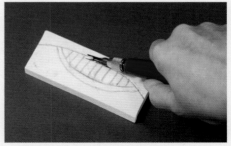

Carve the design.

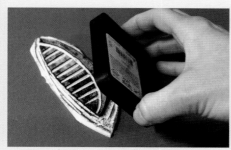

Ink up your stamp using an ink pad, foam brush, or brayer.

The test print

Hand-carved printing blocks and erasers

Stamp-Carving Tips

It takes a bit of practice to get the feel for how hard you need to push the carving blade into the block as well as for the angle and the speed to use, so until you get comfortable with the tools, keep your stamps small and simple.

Take it slow! Don't try to carve too fast or you may find yourself carving off more of the block material than you intended.

When inking your stamp with an ink pad, place the stamp on your table image side up and then tap the pad against the stamp.

Always clean the extra paint off your stamps before it dries or it may clog up your design and make it hard to get a clean print the next time you use it. Baby wipes work great for cleaning ink and paint off stamps.

Store your hand-carved stamps flat with pieces of waxed paper between them so they don't stick to one another.

Artist: **SUE BLEIWEISS**

I often use watercolors on paper as a way to work out and brainstorm design ideas before trying to create them using fabric. Watercolors are my preferred paint for this because they dry fast and I can keep the creative momentum flowing without having to pause to let the paint dry. I like to work with my own hand-dyed fabrics because they lend a more personal feel to my work for me and I don't have to rely on commercially produced colors.

Techniques Used: **WATERCOLOR, HAND-DYED FABRIC**

Instead of working directly in a sketchbook I cut up some 6-inch-square pieces of watercolor paper to work on. I pulled out my watercolors and just started to put shapes of color on the paper without giving it too much thought. For the first few I used several different colors and let them run together. I liked them, but they felt too random and I wanted more structure so I decided to limit myself to only two colors plus black and to use a single repeated shape. My intention was to change the shape for each piece but I liked the first one I did so much that I ended up doing a whole series of them.

Once I had completed twelve watercolor pieces I created a book to mount the pieces in. While I was creating the book I started thinking about how to translate the watercolor drawings using fabric. I also considered painting some deli or butcher paper and creating some torn-paper collages. That idea appealed to me, but I found myself repeatedly coming back to the idea of re-creating the sketches in fabric. I toyed with the idea of doing some silk painting using black gutta (a resist product used in silk painting) for the

lines but then discarded that idea in favor of scanning the sketches and printing them out on fabric.

I printed a few of the designs onto silk fabric, but I couldn't get the rich saturated color that I desired and decided that the only way I was going to get the colors I wanted was to use hand-dyed fabrics.

Patterns and Grids sketchbook by Sue Bleiweiss

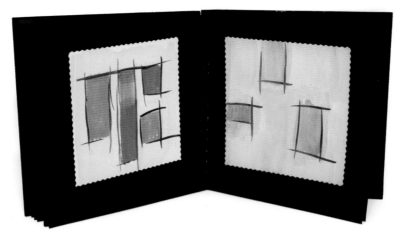

Watercolor pages using several colors that felt too random

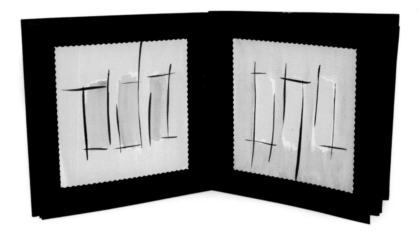

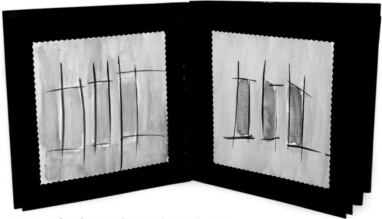

Patterns and Grids watercolor pages by Sue Bleiweiss

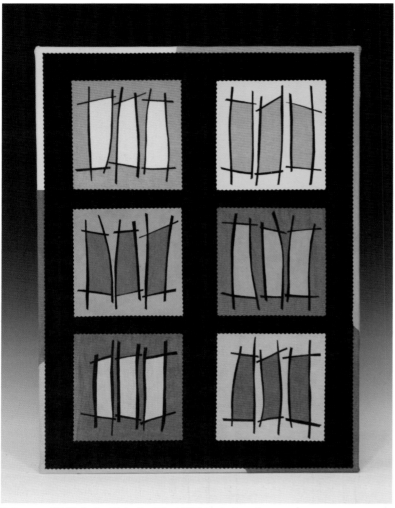

Patterns and Grids *by Sue Bleiweiss (18" x 24" [45.5 cm x 61 cm])*

After putting Mistyfuse on the back of each fabric I wanted to use, I cut the squares freehand with a pair of scissors and fused them to a 6-inch-square piece of fabric that I cut using a deckled-edge rotary cutter. The finished squares were fused to a background fabric and then fused to a stretched canvas wrapped with the fabrics I used in the squares.

I enjoyed working with the imagery so much that at some point I will venture into creating a series of larger scale artworks and will experiment further with different ways to translate them using fabric as the base medium. There are so many more possible techniques to explore; silk painting, quilt piecing techniques, digital printing, and thread sketching are just a few that come to mind.

My method for dying fabric is very easy and tends to produce an unevenly colored surface, which makes for a more interesting piece of fabric to work with.

What You Need

- Procion dyes in your choice of colors
- Soda ash
- Plastic zip bags
- Plastic gloves
- Tablespoon
- Glass jar large enough to hold at least 1½ cups of water, with a tight-fitting lid; mark the 1 cup level on the jar.
- Fabric: Procion dyes work with fibers such as cotton, linen, hemp, and silk. I work with sandwashed cotton and silk habatai (12mm) from Dharma Trading labeled PFD (prepared for dye); otherwise you will need to prewash all your fabric to remove any sizing.

Before you dye, take a few precautions. Wear old clothes and rubber gloves when working with dye and cover your work surfaces with plastic sheeting. Procion dyes pose no airborne health hazard once they are mixed with water. However, when they are in powdered form it's imperative not to inhale them. Wear a mask or preferably a respirator before you open the containers. DO NOT do this in front of a fan or an open window when the wind is blowing. Close the containers as soon as you finish taking the dye, and keep them away from other people and pets.

1 Cut or tear your fabric into pieces that will fit comfortably in your zip bags. I work with either 1 or ½ yard pieces in gallon-sized bags.

2 Mix the dye. The ratio of dye to water is all a matter of personal taste. I mix my dye fairly

A batch of newly hand-dyed fabric

strong because I like rich, saturated color. I use 1 tablespoon of dye to 1 cup of water for 1 yard of fabric. (When I want to get a nice rich black fabric, I use twice the amount of black dye that I normally would and dye the fabric twice.)

3 Add ¼ cup of warm water and 1 tablespoon of dye powder. Screw the lid on tightly and shake well to dissolve. Add enough warm water to bring it to the 1 cup level and shake.

4 Open the jar and add 1 tablespoon of soda ash. Put the lid on, shake, and then pour the dye solution into the bag with the fabric. Squeeze the air out of the bag and zip it closed. Knead the bag to distribute the dye.

5 Let your fabric soak for a minimum of 4 hours or overnight. You may knead the bag occasionally.

6 Rinse the fabrics in cold water. Squeeze out the excess water, toss the fabric into the washer with like colors, and wash with regular detergent. Then toss the fabric in the dryer. Press your fabric with a hot iron.

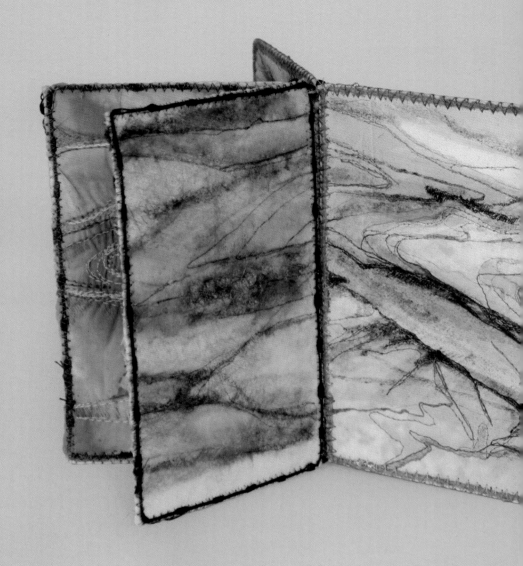

RHYTHM

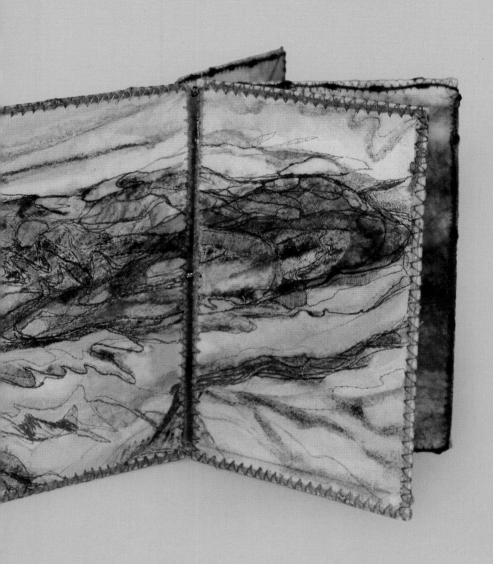

The word *rhythm* has to do with more than just music. Think about exploring the rhythm of nature, the ebb and flow of the tide, or the movement of a dancer as she moves across the stage. Or how about exploring this theme by looking at the symbols used when writing music or maybe narrowing the focus to a particular type of instrument?

Artist: **JACKIE BOWCUTT**

A textile artist residing in the UK with an expertise in creative studies (embroidery), Jackie credits her recent diploma in art and design for introducing her to the medium of creating handmade artists' books, now the main focus of her work.

Techniques Used: **SOY WAX RESIST, MONOPRINTING, MARK-MAKING TO MUSIC**

When I approached this theme, at first I froze and had no idea where to start. I overcame this by concentrating on the word itself, *rhythm,* and the rhythm of writing it. The rhythm of handwriting and of words related to *rhythm* carried me forward. The process of writing was a good place to start.

I used resist techniques and the words from a song, "The Rhythm of Life," to create one sketchbook page and the line of a heartbeat from an ECG and some mark-making to music on the radio to create another. I transferred some of these marks to a polystyrene printing block (a stamp made from polystyrene, a kind of plastic) and used them to print on my sketchbook pages. For my third page, I thickened gouache paint with PVA glue and did some mark-making with it. Then I looked up images of dancing feet and made a rough sketch of these. And, using a paper mask to preserve the white space in the middle of the page, I did some monoprinting using water-based printing inks with the theme "dancing feet."

For me it was necessary to work my way into the theme and let the final ideas evolve. I like working with scrolls and when I found images of pianola (player piano) rolls, I knew how I would translate the Rhythm theme into an artwork. I used soy wax as a resist to make marks similar to those on the polystyrene print block I used for my sketches. I also burned holes in strips of painted fabric with an incense stick to simulate the holes in the pianola rolls. The fabric was then machine-stitched using a double needle to make it roll. Lastly I decided which red thread to use to include the rhythm of handwriting in stitch form.

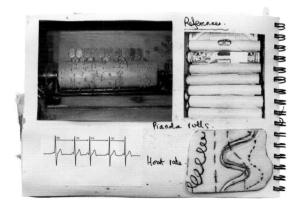

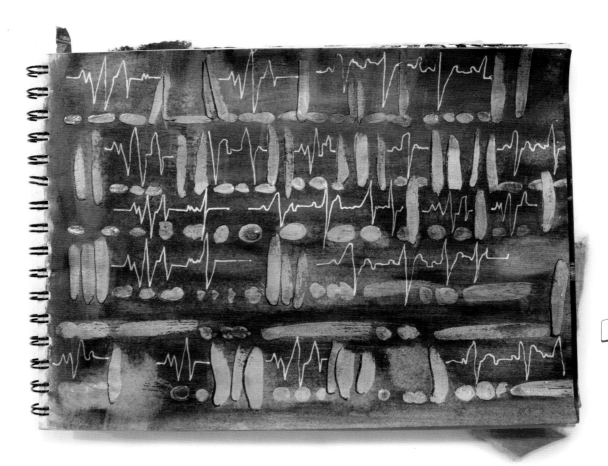

Rhythm sketchbook by Jackie Bowcutt (above and opposite)

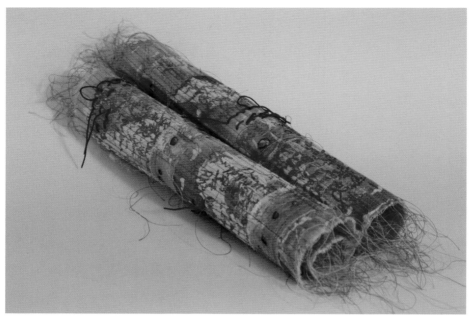

Rhythm *scroll by Jackie Bowcutt, inspired by her sketchbook pages*

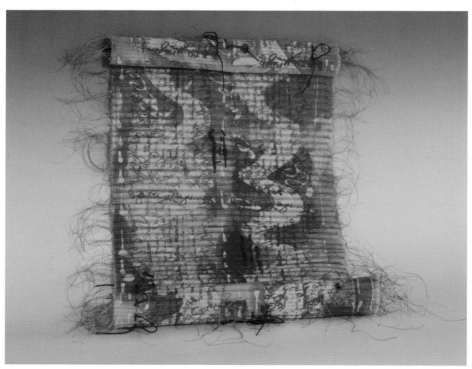

Unrolled Rhythm *scroll by Jackie Bowcutt (9" x 18" [23cm x 45.5cm])*

Please use common sense when working with hot wax: Do not work near an open flame. Do not leave melted wax unattended, and keep pets and children away from the area. Wear appropriate clothing and make sure that your hair and shirtsleeves are tied back and secured. Work in a well-ventilated area, preferably outside. Do not let any water come in contact with the hot wax or it will splatter, and never pour water onto a wax fire. Keep a fire extinguisher or bucket of sand nearby in case of fire.

You can use soy wax as a resist on both fabric and paper. One of the advantages of working with soy wax as a resist for fabric is that it is water soluble, meaning that it dissolves in water. This makes it easy to remove from the fabric without having to rely on dry cleaning methods. Because it is water soluble it's not suitable for using with immersion-dye techniques, but it works perfectly with thin textile paints such as Jacquard Dye-na-Flow. When using soy wax as a resist on paper, you'll use the heat of the iron to remove it rather than water.

Melting Soy Wax

It's very important not to overheat the wax!

At high temperatures the wax will put out hazardous vapors and ignite. Do not melt your wax over an open flame such as a gas or propane burner. Soy wax in flake form melts between 130 and 150 degrees Fahrenheit, so it's not necessary to use high heat and you should never get the wax hot enough to bubble or smoke. Melt your wax in a craft-dedicated Crock-Pot or an electric skillet that you will never use for food preparation using a low temperature setting. When you're done using the wax,

just let it cool and harden in the skillet; then when you're ready to use it again, just re-melt it.

Applying the Wax

You can purchase tjaps—strips of copper worked in fabulous patterns traditionally used for batik printing in Java—from specialty suppliers for stamping with wax, but take a look around the house first for items you can use to stamp with. Any tool that can take being exposed to the heat of the wax can be used as a stamp. Old metal cookie cutters, found objects such as wire baskets, and old cooking tools such as potato mashers will create intriguing marks on your fabric or paper.

Supplies for soy wax resist: wax, electric skillet, cookie cutters, potato masher, wire basket, and copper tjap

You'll get better results if you work on a padded surface. Place a couple of old towels on your worktable, cover them with a piece of plastic, and then place an old sheet or a piece of scrap muslin or cotton fabric on top. Place your fabric on top of the sheet and you're ready to start stamping.

When working with metal objects for stamping, hold them in the wax for a few moments to allow them to warm so that the wax doesn't cool on

Lift the wax stamp straight up off the fabric.

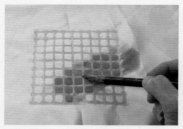
Brush your paint across the surface right over the wax.

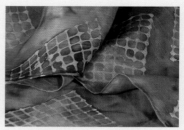
The finished fabric.

them too fast when you pull them out. Place the item you want to stamp with into the wax. Lift it straight out of the wax, letting the excess drip off, and then immediately press it onto the fabric. Hold it against the fabric for a few seconds to make sure that the wax penetrates through the fabric. Then lift it straight up off the fabric.

Make sure that you apply enough wax to the fabric so that it penetrates through to the other side or when you start painting the color may migrate to other areas of the fabric or flow underneath the wax itself.

Adding Color

When you are finished applying the wax, allow it to cool completely before painting. Then, simply dip your paintbrush into the paint and brush it across the surface.

When you are finished painting, let the fabric dry completely.

Removing the Wax

Because soy wax is water soluble you can just soak your fabric to remove the wax, but first you must heat-set the paint or you'll wash away all your color. To heat-set the paint before removing the wax, place

some sheets of newsprint on your ironing surface. Put your fabric on top, cover it with a piece of newsprint, and iron with a hot iron.

As the heat penetrates through the layers, the wax will melt and the newsprint will absorb it. Depending on how much wax you've used and how large your piece is, this process may take awhile. As the newsprint becomes saturated with wax, replace it with fresh sheets and continue ironing. (If you used paper instead of fabric for your project, use this same method to remove the wax from the paper.) It's important to make sure that you spend a good amount of time ironing the fabric because not only are you removing the wax but you are also setting the paint. If you don't spend enough time on this step, then some of the color may come out in the wash.

Once you are finished with the ironing step, your fabric is ready to be washed. There may be some residual wax left on the surface of the fabric, so it's a good idea to rinse the fabric first in some warm water to help dissolve any leftover wax before putting it into your washing machine. Wash your fabric in warm or hot water with regular detergent. It may take more than one wash cycle to completely remove all the leftover wax from the fabric.

Artist: **LAURA CATER-WOODS**

Laura is obsessed with the idea that time in its abstract sense is reflected in diverse and seemingly opposing ways. Manipulating cloth, paint, and surface allows her to explore formal and conceptual issues and to find unexpected metaphors in the process.

Techniques Used: **PEN AND PENCIL, PAINT, STITCHING**

To me the word *rhythm* always implies the cycle of the seasons, the lines and forms that reflect time and change. So I saw contours, spiraling forms reflecting both water and the mark of time and wind on land. I made some basic sketches, line drawings using pen or pencil to depict what I saw along the river and in the small details from landscape. I was concerned that some might prefer a more literal approach to the theme, but the lines and forms of water, the repeating colors are rhythmic. . . .

Almost immediately, I knew my finished piece (page 97) would be about seasonal change, that it would be three-dimensional and would take on its own life. So there was nothing to do but jump in. I drew lines onto raw tea bag paper that I fused to Peltex (stiff interfacing). Paint and stitching were applied and the panels were assembled. I wanted a two-sided freestanding piece. At some point another set of panels was interjected. Part of my intention was that the panels might be seen in different relationships to one another.

Sketchbook page by Laura Cater-Woods

Sketchbook pages by Laura Cater-Woods

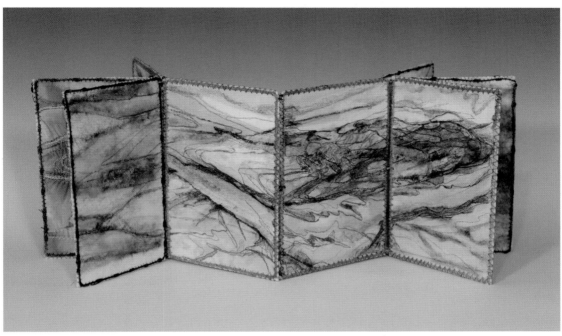

Season Unfolding *(side 1) by Laura Cater-Woods (6″ [15cm] tall)*

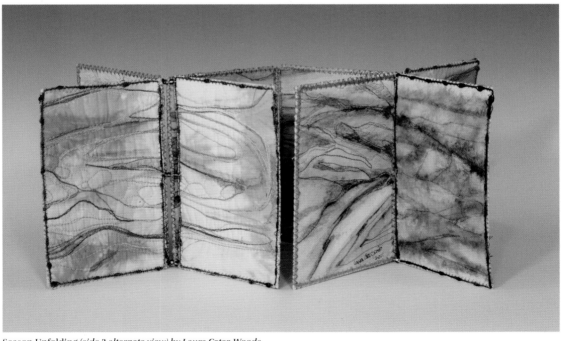

Season Unfolding *(side 2 alternate view) by Laura Cater-Woods*

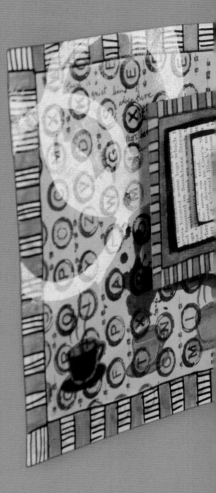

SIMPLE
PLEASURES

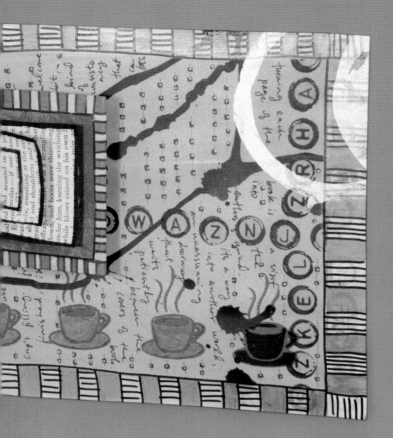

The theme Simple Pleasures is all about slowing down long enough to take stock of all those moments that make you stop and smile. It may be something as simple as seeing the first buds of spring peeking through the ground, finding a quiet moment to sit in the garden with a cup of tea listening to the birds, or cozying up with a hot cup of coffee in front of a warm fire on a cold rainy day.

Artist: **LESLIE TUCKER JENISON**

Leslie Tucker Jenison is inspired by the textural beauty found in the patterns of natural and man-made environments. She loves the tactile experience of working with cloth and paper. Using dye, paint, and thread, Leslie creates unique imagery on these surfaces. The juxtaposition of the macro- and microscopic worlds is a recurring theme in her work.

Techniques Used: **PAINT, INK, IMAGE TRANSFERS, SCREEN PRINTING, FOILING, STAMPING, COLLAGE**

THE N0

THE SKETCHBOOK CHALLENGE

"Simple Pleasures" conjures up many images for me. With the passage of time I have learned to savor the small pleasures of each day, as well as the treasure of my memories. I hope my pages will reflect a few of these things.

I chose to work on loose pages as I intend to have them custom-bound when I am finished. One of the reasons for this is I wanted to experiment on a variety of papers, and another is that I wanted to incorporate some screen printing on some pages, which is challenging to execute in a bound book. I love the freedom of mixed media! It allows me to incorporate a variety of materials that help me tell a story on each page. I used watercolor paper, acrylic paint, alcohol inks, watercolors, gouache, gel medium, Transfer Artist Paper, Thermofax screens created from my personal drawings, handmade stamps, Lutradur, mulberry paper, metal leaf, book pages, graphite pencil, Staedtler pens, Pitt pens, photo transfer, and ephemera from travel (including car rental maps, tags, and receipts).

The beautiful thing about working on sketchbook pages is that little things often do become bigger things. Perhaps not immediately, but once they have been committed to the page, they are a resource for the future.

For my finished piece, I had a collage in mind because I could layer things of importance about the subject, such as writing, imagery, texture, and color. The first step was to gather some of those items and play with them on the page. The layering of media and ephemera adds visual depth to the page, inviting the viewer to consider what is there in a personal way. My hope is the viewer finds her own story within the work. That said, I also hope something of my own story touches the viewer and invites her in.

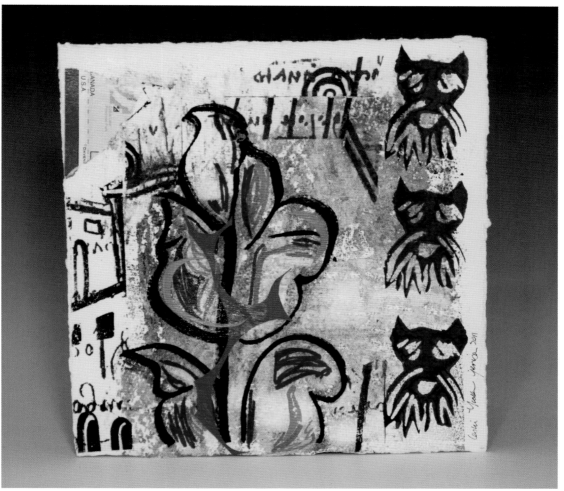

Dogs in the Garden *sketchbook page by Leslie Tucker Jenison*

Tea and Poetry *sketchbook page by Leslie Tucker Jenison*

The Snappies in My Garden *sketchbook page by Leslie Tucker Jenison*

Come into My Garden and Know Who I Am *sketchbook page by Leslie Tucker Jenison*

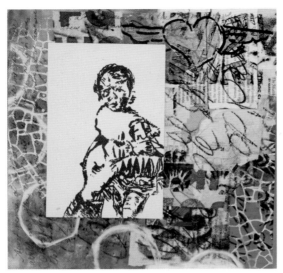

Memories of Childhood Adventures *sketchbook page by Leslie Tucker Jenison*

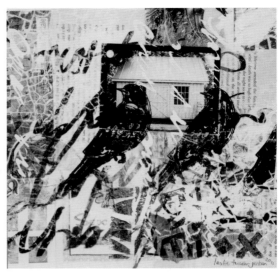

Memories of Crows *sketchbook page by Leslie Tucker Jenison*

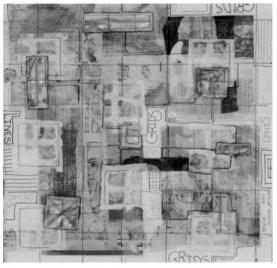

Lines and Grids *sketchbook page by Leslie Tucker Jenison*

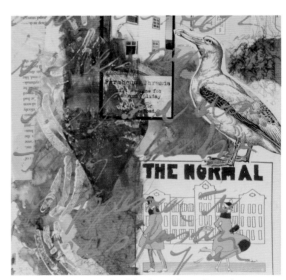

Maps and Wanderlust *sketchbook page by Leslie Tucker Jenison*

There are a lot of different ways to transfer images from one substrate or surface to another. One of the easiest ways is to purchase ready-made image transfer sheets (there are several brands on the market and you can find them in fabric, art, and some office-supply stores) that transfer what is printed on them to another surface using the heat of an iron. These sheets typically give you a clear transfer but sometimes you may find that you want a more rustic or ethereal transfer.

Supplies for image transfers: Citrasolv, toner-based copies, chip brush, and a spoon

Citrasolv is a cleaning solvent that can be used as a medium for transferring images to fabric, metal, paper, and other surfaces, but it will only work with an image that has been printed onto paper using a toner-based cartridge. Ink-jet prints will not work for this technique.

1 Print your image using a toner-based copier or laser printer.

2 Place your printed image print side down on your fabric and paint the back of it with a brush dipped in Citrasolv.

Brush on the Citrasolv.

3 Burnish the back of the image with a spoon. You'll need to experiment a bit with how hard to rub.

4 Lift the paper to reveal your transferred image.

Burnish the back of the image with a spoon.

Tips for Transfers

You can use acrylic gel mediums to transfer images from a wide variety of sources such as ink-jet printers, magazine pages, and photocopies. Gel mediums come in several different weights so experiment to find the one that works best for the surface you are transferring onto. Just coat the surface that you're transferring onto with a layer of gel medium and then place the image you want to transfer facedown on top and press it into the surface. Let it dry completely, then dampen the paper with a wet sponge and carefully rub off the paper to reveal the transferred image.

Lift to reveal the transfer.

Artist: LYNN KRAWCZYK

Lynn is a mixed-media artist obsessed with screen printing and creating assemblages. Happiest when creating, she is also an avid writer and enjoys mixing fiber with other materials to create a juxtaposition of textures and surfaces.

Techniques Used: SCREEN PRINTING, STAMPING, STITCHING

I firmly believe that it is the little things in life that bring us joy. Often our daily habits are centered around these activities, so when I considered this theme I immediately thought of my love of drinking coffee and writing. Writing is a constant in my life that I always enjoy, whether I'm writing fiction, a magazine article, a blog post, or just random thoughts. I've filled dozens of journals with my writing. And coffee is my companion during that activity, so they seem to work together naturally.

I like to turn my sketchbooks into art journals that I build from scratch and theme out. I love the challenge of creating different shapes or different sizes for the pages. I wanted to mimic the journal that I use for my writing, which is a very simple lined book. It is actually pretty scruffy, with coffee cup stains, scribbles, and doodles. These characteristics are reflected in the journal that I created for the theme. I used a heavy hot press watercolor paper and cut it to the size I wanted. I folded it so that the cover of the journal would be shorter than the back cover, exposing the interior. I painted the paper with gold Dye-na-Flow paint and then splattered brown Dye-na-Flow on it and hung it to dry so the splatter would run down in organic lines.

I added the coffee cups and stain images with Thermofax screen printing. I blotted the white stain images with paper towel to give them some texture.

I created a mini book from a screen-printed paper and pages from an old book and stitched it to the larger book using a simple binding stitch. I added a gold coffee bean charm for some movement. Once I fill every available space on my sketchbooks, I move on to the fabric piece.

I knew when I began that I wanted to do a fabric piece (opposite, top right) to accompany the journal. It seemed in keeping with the coffee part of my interpretation of the theme: I once bought organic coffee beans that came in a burlap sack and my mind immediately snagged on that image. While the fabric I used for the art quilt is osnaburg, a much smoother fabric, it still has the feel of that burlap sack. I used coffee stain images (also Thermofax screen printing) and the large coffee cup image. I stitched steam coming from the cup and added a larger piece of fabric that created a border similar to coffee splatters to frame the screen-printed fabric.

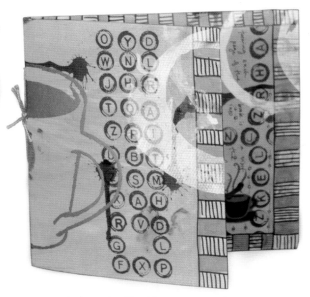

Simple Pleasures sketchbook by Lynn Krawczyk

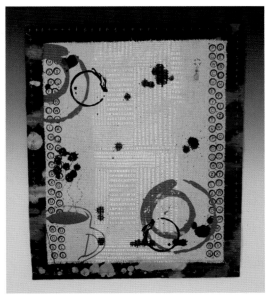

Simple Pleasures wall hanging by Lynn Krawczyk (15½" x 18½" [39.5cm x 47cm])

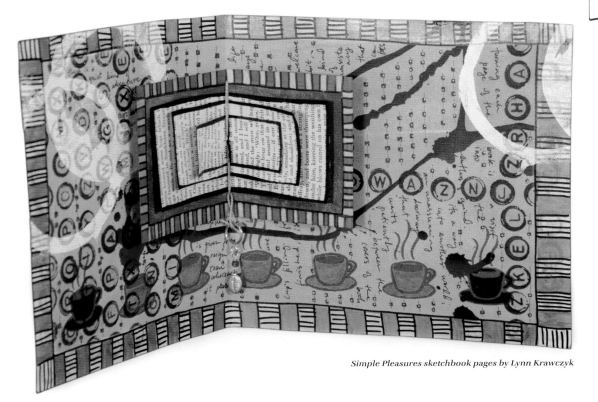

Simple Pleasures sketchbook pages by Lynn Krawczyk

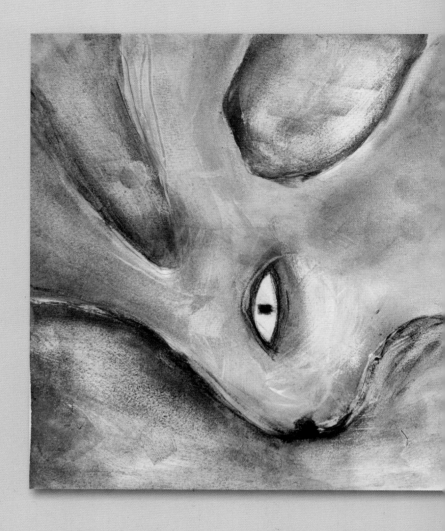

SYMBOLS

Everywhere you look you'll find a symbol, from the stop sign at the end of the street to the logo on your sneakers. Ancient texts are filled with all sorts of fascinating symbols and a trip to a museum may inspire you to look closer at the artwork in your search for symbols to explore.

Artist: **CARLA SONHEIM**

Carla Sonheim is a painter, illustrator, and creativity workshop instructor known for her innovative projects and techniques. She advocates a spontaneous, playful approach to creating.

Techniques Used: **PENCIL, WATERCOLOR, TOMBOW PEN, INKTENSE PENCILS, CHARCOAL, PANPASTEL, CONTE CRAYON**

To be honest, when I first learned that Symbols was the theme I was working with, I panicked. I'm not sure why, but the "bigness" of the topic scared me. So the first few weeks of the project I avoided even thinking about it consciously. Like anything, though (exercise, falling asleep, drawing), once I just relaxed, ideas began to form and clues began to appear.

Even though I have been drawing and painting rabbits on and off for a long time, they started appearing more often in my sketchbook for some reason.

Then my son and daughter-in-law Skyped us from China telling us that they were expecting their first child—our first grandchild! The news happened to come right at the Chinese New Year: the Year of the Rabbit.

It was a curious coincidence (this rabbit thing), so I looked into the Year of the Rabbit and realized that . . .

- I was a rabbit! (Born 1963.)
- My son was also a rabbit! (Born 1987.)
- And my grandbaby would be, too! (To be born in 2011.)

I had some time to paint bigger a few weeks later and did a series of rabbit paintings based on the loose drawings in my sketchbook. After all this, I realized that the rabbit was my symbol.

Before starting the paintings, I decided to dedicate a small sketchbook to the rabbit. I drew from photos and from my imagination. I was trying to experiment with incorporating words in my art journal, but in the end didn't like my handwriting and so obscured most of them. But the text that runs throughout the twelve-page journal is a description of those born in the Year of the Rabbit (I admit I quite like that rabbits are supposed to be "talented").

I felt ready to move on to the painting (see page 111) after only the first three pages of the sketchbook! But I know the value of drawing from life before moving to primarily imaginary work (which is how I usually approach my paintings), so I stayed the course until the end. I'm a strong believer that drawing from life or from photo references is important for making my stylized work more authentic. I didn't spend a huge amount of time drawing rabbits from references, but I did do it. (And enjoyed it!)

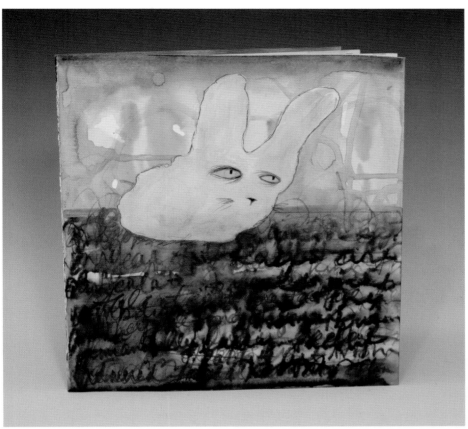

Year of the Rabbit *sketchbook cover by Carla Sonheim*

Year of the Rabbit *sketchbook pages by Carla Sonheim*

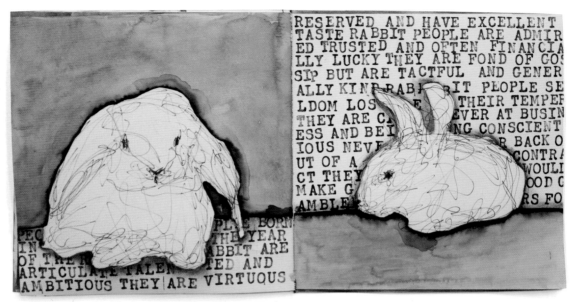

Within the image:
RESERVED AND HAVE EXCELLENT
TASTE RABBIT PEOPLE ARE ADMIR
ED TRUSTED AND OFTEN FINANCIA
LLY LUCKY THEY ARE FOND OF GOS
SIP BUT ARE TACTFUL AND GENER
ALLY KIND RABBIT PEOPLE SE
LDOM LOS E VER AT BUSIN
THEY ARE C NG CONSCIENT
ESS AND BEI R BACK O
IOUS NEV CONTRA
UT OF A WOULI
CT THEY OOD C
MAKE G RS FO
AMBLE

PE PLE BORN
IN THE YEAR
OF THE R ABBIT ARE
ARTICULATE TALEN TED AND
AMBITIOUS THEY ARE VIRTUQUS

Year of the Rabbit *sketchbook pages by Carla Sonheim*

I experimented with several different media (Tombow markers, PanPastels), and considered incorporating those into the final painting, but in the end I stayed with what I knew and was comfortable with.

I've found over the years that I need to approach the canvas the same way I would the sketchbook; that is, with few preconceived ideas of what the final outcome will be. In other words, even though I was aiming for a rabbit, I knew in my heart that it might turn out looking like a dog instead, since

I don't use photo references when I paint. I start out by slapping the watercolor and gesso on the canvas, then going back in with sandpaper once it dries to make scratches. Then I start looking for the hidden rabbit. Most of the time I see something. If not, I repeat my first steps.

I almost never know exactly when a painting is done for sure. Usually I just get stuck and don't know what else to do, so I stop for a while. Nine times out of ten I look at it after a few days and call it finished.

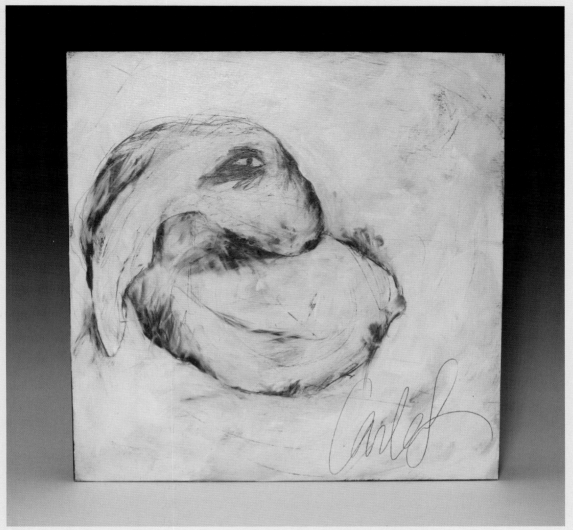

Year of the Rabbit by Carla Sonheim (12" x 12" wood panel [30.5cm x 30.5cm]), inspired by her sketchbook

Artist: **VIOLETTE CLARK**

> Violette Clark is a mixed media artist, author, designer, workshop instructor, and creative catalyst. Her passion is to teach others to embrace who they are through the vehicle of their creativity.

Techniques Used: PEN, ASSEMBLAGE, MARKERS, WATERCOLOR CRAYONS, PAPIER-MÂCHÉ

I wanted to focus on symbols since they have always played a major role in my life. I had a vague notion I wanted to do something with the Virgin Mary since she symbolizes compassion, peace, and love to me. The problem was simply beginning. I had so much on my plate and began procrastinating about tackling this project. The more I procrastinated, the harder it became to start. Finally, I couldn't wait any longer and simply began.

I began sketching with a Micron pen. My goal was not to create a "pretty page" but just to use the page as a dumping ground for ideas, thoughts, and inspiration. I added a bit of color with Copic markers to better visualize how my project could look. I was thinking on paper—"Do I want to use a real statue of Mary or use a drawing I create?" Once I got these questions out of my head and onto paper, the answers began coming to me. I don't often use a sketchbook to flesh out ideas but loose pieces of paper—even Post-it notes! It usually only takes me a couple of pages to expand on my ideas. I really enjoy this part of the process (that is, once I have begun).

The problem is I can get too comfortable here and not move off of the page. That was another hurdle to overcome. I had to force myself into the studio in search of a substrate or surface for my shrine (page 114). My studio is bursting with frames, boxes, canvases, and collaged backgrounds, so once I was in the studio, choosing was easy.

Mary's face was drawn and inked with Micron pens—color was added with Copic markers and watercolor crayons. Then the image was cut out and adhered to another piece of card for stability. The halo was hot glued to the back of the head.

I decided to go against a traditional shadow box shape and instead use a cradle board, which has a rounded top. The board was collaged with a variety of papers and stickers and then painted. Pieces of text and images peek out from beneath layers of paint. I created marks with lids used as stamps, drips of paints, and credit cards. The frame was cut from a piece of foam core. Tissue paper was Mod Podged over the edges to cover up rough spots.

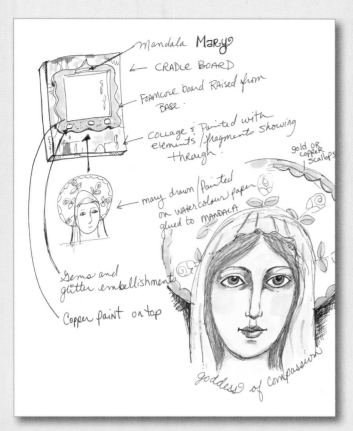

Mandala **Mary**

← CRADLE BOARD

← FOAMCORE board RAISED from BASE.

← COLLAGE & Painted with elements / fragments showing through.

gold OR copper scallops

← mary drawn / painted on WATER colour paper glued to MANDALA

Gems and glitter embellishments

Copper paint on top

goddess of compassion

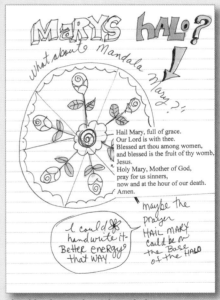

MARYS HALO?

What about Mandala Mary?!!

Hail Mary, full of grace.
Our Lord is with thee.
Blessed art thou among women,
and blessed is the fruit of thy womb,
Jesus.
Holy Mary, Mother of God,
pray for us sinners,
now and at the hour of our death.
Amen.

I could hand write it. Better energy that WAY.

maybe the prayer HAIL MARY could be on the Base of the HALO

Sketchbook pages by Violette Clark

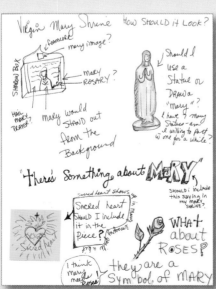

Virgin Mary Shrine How SHOULD IT LOOK?

foamcore

SHADOW BOX

mary image?

MARY ROSARY?

HAIL MARY PRAYER

Should I use a Statue or DRAW a "mary"? I have 4 mary statues - am I willing to part w one for a while?

MARY would STAND OUT from the Background

"There's Something about **MARY**"

Sacred heart shows

SACRED heart SHOULD I include it in the piece?

Should i include this saying in my MARY SHRINE?

Sacred Heart

WHAT about ROSES?

I think mary means roses!

they are a symbol of MARY

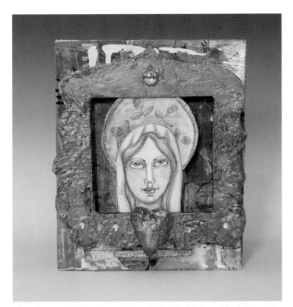

There's Something About Mary *shrine by Violette Clark (8" x 10" [20.5cm x 25.5cm])*

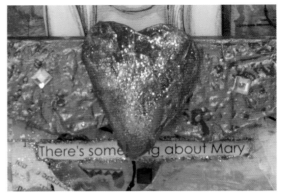

Heart detail, There's Something About Mary

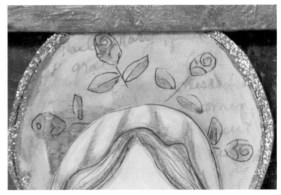

Halo detail, There's Something About Mary

Stucco plaster was applied to the frame for a bumpy look. When the frame was dry, several different colors of acrylics were randomly painted on top. I then rubbed copper paint over the frame with my fingers.

A papier-mâché heart was created, painted red, and then covered with glitter. It was adhered to the frame, as were some gems and a flat-bottomed marble. I enjoy creating shrines, so this was a very natural way for me to interpret the theme. I also very much enjoy drawing—especially faces, so creating a two-dimensional Mary was an absolute delight.

A touch of foiling can add a nice bit of shimmer to excite the eye about a piece of artwork. You can buy foil in several different formats. Metal leaf comes in paper-thin sheets and is available in several colors including copper, gold, and silver. Sheet foil or foil paper is a high-gloss mylar that has been attached to a pull-away backing.

A selection of foils

There are special glues that you can buy to use with foiling, but I have found that Golden soft gel medium works just as nicely and since I always have it on hand in my studio, it's convenient. You can brush it onto your fabric, stamp it on, or apply it through a silk screen or stencil. I've applied it to my fabric using a silk screen image of a dragonfly for this example. When the medium is completely dry, place a piece of metal leaf over it.

Cover the dry gel medium with a piece of metal leaf.

Cover the metal leaf with a piece of parchment paper and press with a warm iron.

The heat of the iron will activate the gel medium and the metal leaf will bond to it. Gently lift off the parchment paper and use a soft brush to brush away the excess metal leaf to reveal your design

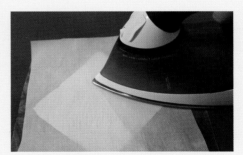

Cover with parchment paper and press with a warm iron.

Foiling Tips

Wash gel medium out of your brushes and silk screens right away. Do not allow the medium to dry or it will ruin your brush and your screens!

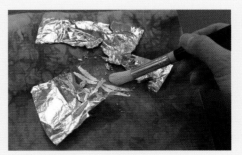

Brush off the excess metal leaf.

shooting stars that fall into
are the enchanted wishes a
decorate the ocean deep

TREASURE

become Starfished... they
of those who sleep to
from the Sea

At first the word *treasure* may make you think of shiny gems and jewels, but take a moment to dig a bit deeper about what you really treasure. There's much more to this theme than what lies on the surface. Family, pets, and relationships come to mind, of course, but what about the sight of the first hummingbird of spring, a favorite mug, or even a vintage remembrance passed down from previous generations?

Artist: **KATHY SPERINO**

A professional long-arm quilter, Kathy Sperino draws on her love of nature to inspire much of her work. Using mixed-media techniques coupled with traditional quilting techniques, Kathy creates quilts that make you stop for a closer look.

Techniques Used: **SILK FUSION, TRAPUNTO, QUILTING**

I immediately liked the theme Treasure. I'm fortunate to have large windows in my studio, and bird-watching is a great love of mine while working. So it seemed like the perfect fit to choose a bird subject to go along with the Treasure theme.

My sketchbooks are working books where inspiration, quilting designs, sketches, and ideas are jotted. I keep several unorganized books of varying sizes and generally only use a pencil and gum eraser. When I'm designing a project such as *Treasured Feathers* (opposite), a rough sketch is added to my sketchbook with notes regarding size, color, and materials. Using this sketch as a starting point, I go back through my books and look for more elements and ideas.

Once my ideas are formalized, they are transferred to paper, which is the same size as the finished piece will be. At this point I'm anxious to move right into choosing and cutting fabrics. Using the sketch as a guide, I begin pinning and stitching fabric elements together.

Having recently experimented with silk fusion fiber (sometimes referred to as silk paper), I wanted to incorporate this technique. Using the sketched cardinal, a pattern piece was drawn and then copied onto the bright red silk fusion. Several times I went back to the sketch in order to resize and check the bird's position on the tree limb. Traditional trapunto (a puffy, decorative quilting method using at least two layers, the underside of which is slit and padded) was used to make the cardinal three-dimensional. Using bits of silk fusion, silk cocoon, and thread, similar dimension was added to the tree, plant stems, and leaves.

My original sketch shows a window concept. After several attempts I realized this design did not translate well onto fabric so I abandoned it. This is not an uncommon process for me; I call this the adding and subtracting step. In the end a plain traditionally quilted border suited this design.

I have kept working sketchbooks for as long as I can remember, and I love to page through my older books. It is fascinating to see the evolution from paper and pencil to fiber and stitch. Having experimented with several computer drawing programs and tablets, I seem to always find my way back to the paper sketchbook.

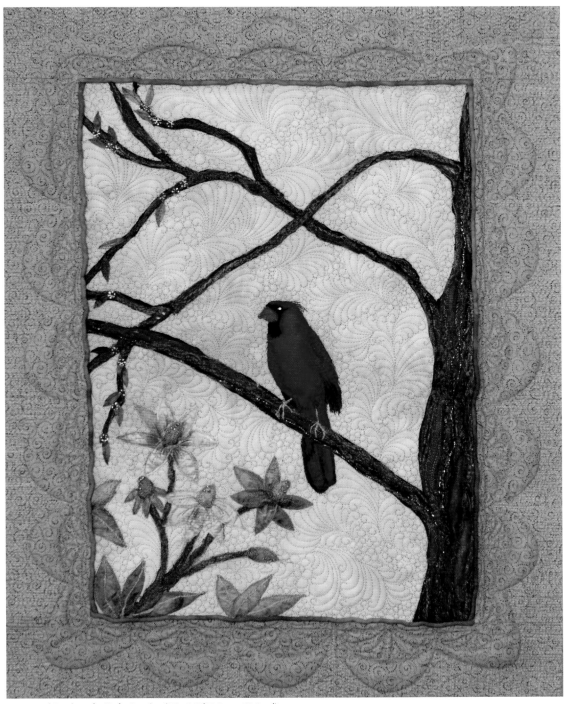

Treasured Feathers *by Kathy Sperino (16" x 21" [40.5cm x 53.5cm])*

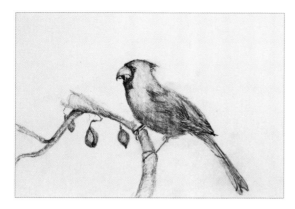

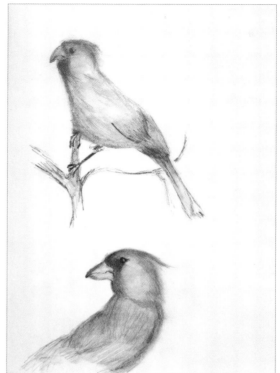

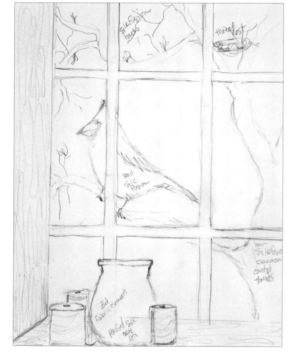

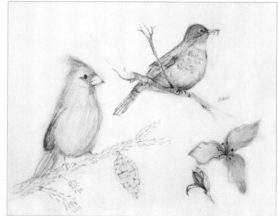

Sketchbook pages by Kathy Sperino

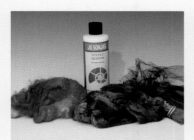

Supplies to make silk fusion: textile medium, silk roving, netting, and chip brush

Cover the netting with short lengths of the silk fibers all going in the same direction. Then cover the first layer of silk fibers with a second at right angles.

Paint both pieces of netting with hot water mixed with dish soap and then with a coating of textile medium.

Kathy used a piece of silk fusion to create the bird for her artwork. Silk fusion (or silk paper) is easy to make and the result is a sheet of silk resembling a piece of fabric that can be treated just as you would any other fabric.

What You Need

- Silk roving (soy silk, tussah, or mulberry)
- Textile medium (I prefer to use the Jo Sonja brand)
- Liquid dish soap and hot water
- Netting or tulle (any color, but I prefer to use black because it's easier to see)
- Chip brush at least 1 inch wide

Put a piece of netting a little larger than the sheet of silk fusion that you want to make on your work surface. Staying a couple of inches in from the edges, cover the netting with short lengths of the silk fibers all going in the same direction, overlapping them slightly to create the first layer of silk.

Once you have laid down your first layer, add another one on top at right angles to the first layer.

Cover the silk with another piece of netting and use a paintbrush to paint both pieces of netting with hot water mixed with a teaspoon or two of liquid dish soap. Hot water helps the fibers to relax and open so that the textile medium can penetrate through. Make sure that the silk is totally saturated.

Brush a coating of textile medium on both sides. Brush on the textile medium right through the netting, on both sides

Hang your fusion to dry completely without removing the netting.

When your sheet of silk fusion is completely dry, remove the netting and iron both sides with a hot iron to set the textile medium. Once it's pressed, your fusion is ready to use.

Artist: **TRACIE LYN HUSKAMP**

Tracie Lyn Huskamp has a passion for mixed media and painting, as well as a love of nature, which shows up in her art journals and is a recurring theme in her work. She is a fabric designer and the author of *Nature Inspired: Mixed-Media Techniques for Gathering, Sketching, Painting, Journaling, and Assemblage.*

Techniques Used: **PASTELS, COLLAGE, THREAD SKETCHING, FABRIC PAINTING**

I absolutely swooned over the Treasure theme. Life is such a gift and our skills, abilities, and talents are the treasures we have the opportunity to share. Most of my artistic focus centers around nature subjects. This large and varied theme constantly provides inspiration and affords me the chance to slow down from the often frantic daily pace to observe the beauties and the wonders of this earth.

I was mostly driven to illustrate the starfish because of my travels to the Pacific and Atlantic oceans, along with rereading a favorite book, *Gift from the Sea* by Anne Morrow Lindbergh, in preparation for my journeys. And the starfish has great symbolism, representing inspiration, brilliance, vigilance, intuition, and guidance. It has been said to be a star that fell from the sky into the ocean.

I chose to use a favorite medium, artist's, or soft, pastels, to illustrate the subjects on each journal page. The colors of pastels are quite lush and vibrant and, by using a blending stump, I can achieve a soft velvety look. I also enjoy illustrating on brown packing paper, which creates a warm muted backdrop to

the intensity of the colors. As a secondary element on one of the journal pages, I incorporated various fabric swatches. It is a wonderful way of enticing a viewer to want to touch the page.

Once I had settled on a theme, the sea; picked a main subject, a starfish; and decided on what mixed-media elements I would incorporate in the work, such as paint, fabric, and stitching; I had a foundation to begin the final artwork. The most difficult aspect of translating my ideas into a finished work was the juxtaposition of the shore and the sea. I was unsure how I wanted to represent the dramatic change in landscape. I drew multiple thumbnail sketches to determine a pleasing shape and ratio of land to water.

Another difficulty was representing the frothy breaking waves of the ocean. Free-motion stitching a beautiful quote from *Gift from the Sea* using white thread was the perfect solution. Since the words did not fill the entire space, the addition of net fabric adorned with silver sequins gave the appearance of waves that were farther from shore.

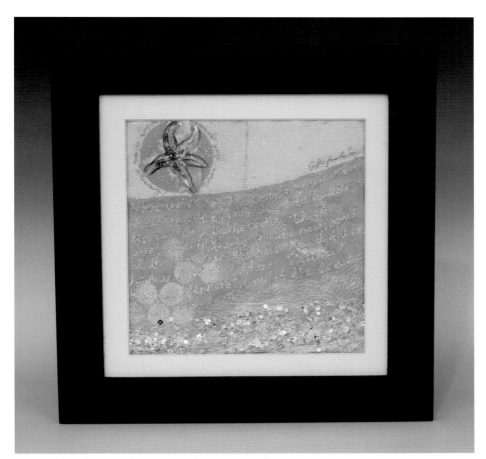

Treasure *by Tracie Lyn Huskamp (12" x 12" [30.5cm x 30.5cm])*

The beginning of a journal page comes from the spark of an experience. I then weave this inspiration into both artistic images and words. Oftentimes, I have my camera in hand or close by, ready to snap a photo of a particular scene that moves me. This photo serves as only a small start in the development cycle. An art journal, for me, feels much like a diary. Keeping a diary was something I tried over and over to do as a child with little success, but art journaling has been an incredible activity, as it combines both images and words into a visual tapestry, recording the days of my life by capturing both significant and daily events.

Treasure sketchbook page by Tracie Lyn Huskamp

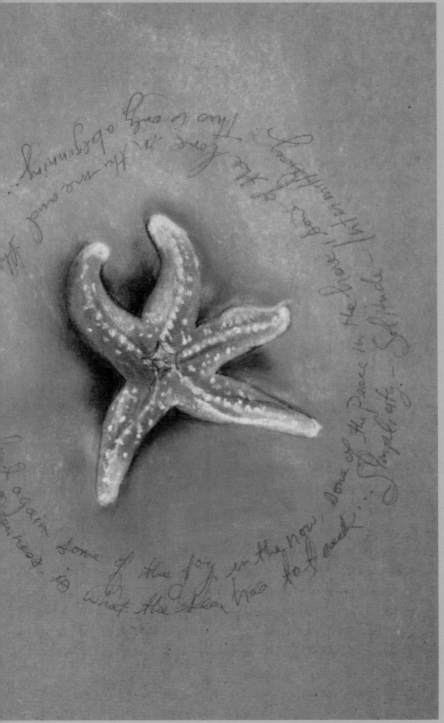

Treasure sketchbook page by Tracie Lyn Huskamp

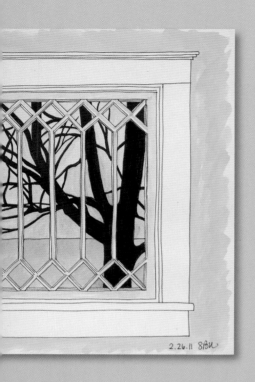

2.26.11 SBW

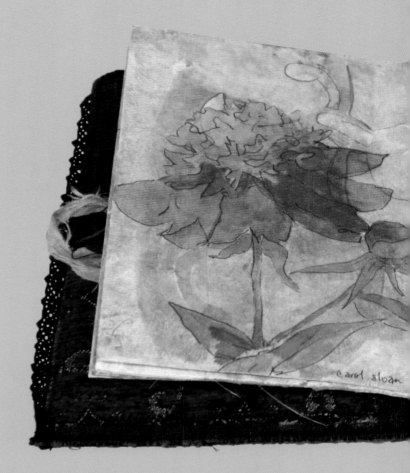

carol sloan

VISTAS
AND VIEWS

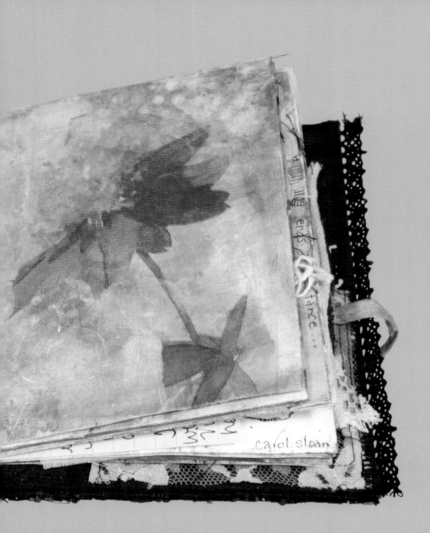

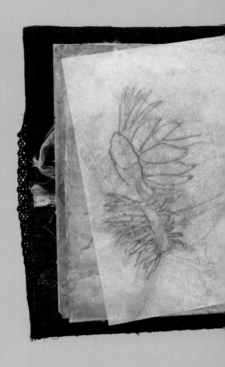

When you look out your window, what do you see? Consider exploring that view at different times through the day or as the seasons change. You could also take a more abstract approach to this theme and express your viewpoint about a current event or personal subject.

Artist: **SUSAN BRUBAKER KNAPP**

An artist who works in fabric and thread, Susan finds great joy in creating works that draw people closer and invite them to savor color and texture. All of her art is a deep expression of her values and a succinct statement about her hopes for and concerns about our world.

Techniques Used: **LINE DRAWING, WATERCOLOR, FABRIC PAINTING, QUILTING**

First I thought about amazing architecture, like castles and cathedrals, or beautiful natural vistas, like mountain ranges or vineyards in Europe. The Views theme made me consider how things look through eyeglasses, car windows, from skyscrapers, through a fence, or from an unusual vantage point. At first, I desperately wished I could be somewhere with amazing views to sketch, like in the mountains or in a city with gorgeous buildings. After dwelling on this for a few days, I decided that I couldn't afford an exotic vacation, and I needed to look closer to home. On one beautiful, clear winter day, I found myself admiring the view out of my bedroom window, and thought to myself, "Wow, that is spectacular!" Our house was built in 1916, and it boasts several many-paned windows. I loved the way the organic lines of the maple tree outside intersected and interacted with the straight, man-made lines in the window.

When I work in my sketchbook, I almost always start with a simple pencil line drawing, so that was how I approached this theme. I don't shade or do anything fancy. Then I go back and refine the drawing using a fine-tip permanent black marker. After

that, I color in and add shadows and highlights with watercolors, watercolor pencils, colored pencils, or markers. Sometimes I also add cross-hatching as the last step.

As soon as I finished coloring the sketch, I was off and running to start the piece of fiber art based on it. I try hard not to overthink in my process, as I find it leads me into either stagnation or obsessiveness, and the artwork usually suffers from both. I am fairly decisive, so I usually jump right in.

I planned to paint the image on white fabric, using textile paints, and then to quilt it. I wanted the glass, and the view through it, to recede, and the window with its lovely mullions to come forward. So I quilted the view behind the glass heavily, but didn't quilt the tree, because it would have looked flat and not stood out from the sky and grass. I used echo quilting (quilting around the edges of shapes on the surface) around the tree branches. This adds lots of interest, texture, and movement to the piece when viewed up close. One unexpected, and wonderful, consequence of this is that the window panes look like old, wavy glass.

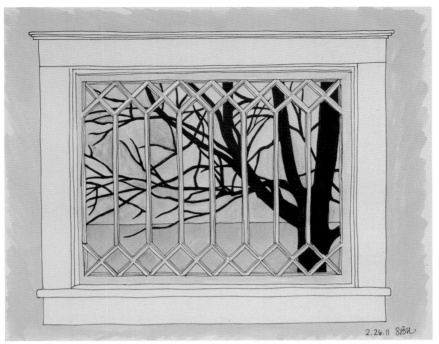

Views sketchbook page by Susan Brubaker Knapp

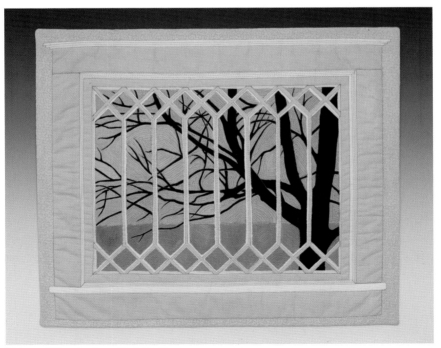

Vistas and Views *by Susan Brubaker Knapp*

Artist: **CAROL SLOAN**

When Carol Sloan isn't creating art with paint, paper, and fiber, she's often kayaking and otherwise exploring nature. One particular kayaking adventure sparked an idea for her sketchbook but organically transformed into something quite different, infused with memories.

 Techniques Used: **PEN & INK, COLLAGE, DIGITAL PRINTING, THREAD SKETCHING**

For some reason, this theme made me immediately think of my view when kayaking. I sketched out an idea for a collage using natural elements and a photo that I had taken while my husband and I were paddling down the river. I was working on the paper fabric collage background using tissue napkins when I was hit with the inspiration for a different piece.

This goes to show you that there are times you have to go with your gut feelings—learn to flow with your creativity and let it lead you instead of fighting for control of it.

I was working in my sketchbook, collaging tissue napkins with flowers on them. The placement of the flower on the page reminded me of a photo I took of my purple coneflowers. I tried to force myself to keep going with the river idea, but, in the end, I got tired of fighting it. I switched a couple of items out and began to let my muse take over. It started to be a lot more fun at this point.

I remembered that my grandmother had purple coneflowers in her flower garden when I was a child. I loved the tall, straight stems with the thick, bulky seed heads on top. These flowers were the only ones that I was allowed to pick, and they would stay intact for more than a few hours, even in my young naturalist "brown bag collection system." Every flower garden that I have planted since then has had coneflowers in it.

Typically I have a loosey-goosey idea for something, sketch or write out an idea or two, and then jump right in to the actual piece of artwork. I designed the mixed-media fiber collage (page 132) around a simple page in my sketchbook. I loved the way that the tissue napkin flower just melded into the painted background. I added a few simple lines around it with an India ink marker to emphasize the shape of the flower. It was at this point that the design went from the sketchbook to the actual piece of artwork even though I continued to jot down different ideas for individual elements. I used fabric paper as the medium for the collage background. I printed out my photo in black and white, then traced the flowers onto a piece of tracing paper to use for the collage background. I painted the flowers with a combination of fabric and acrylic paint and did some thread sketching around the outline.

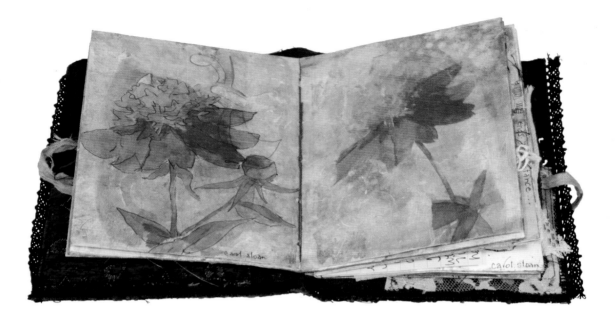

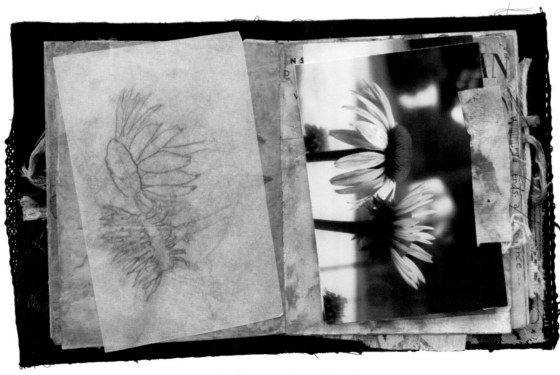

Sketchbook pages by Carol Sloan

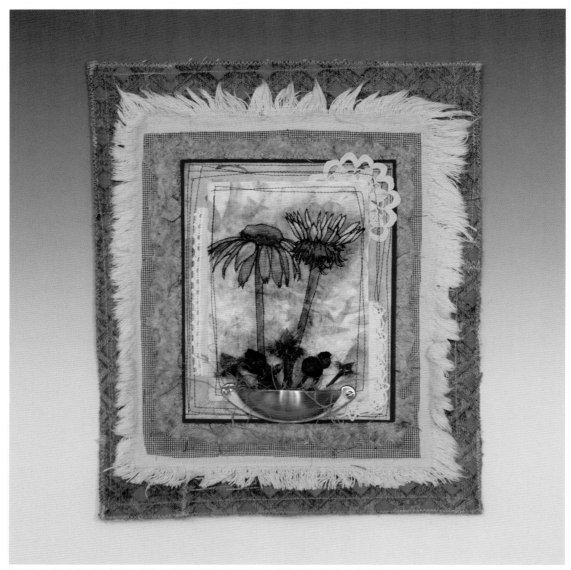

Grandmother's Garden *by Carol Sloan (12" x 14" [30.5cm x 35.5cm]), inspired by her sketchbook*

I named the piece *Grandmother's Garden* in memory
and in honor of my grandmother and her garden. It
spoke of more than just my vista or view of my own
garden but encompassed the view of past memories.
It is in looking forward that we look to the past.

Moldable stamps are a fast and easy way to create a custom stamp. You can get moldable stamp material in sheets, blocks, or fun shapes.

You simply heat up the material with a heat gun by pointing the gun at the surface until it becomes soft, then press it into a textured surface, and you've got a custom stamp. When you want to make a new stamp, you just reheat it and make a new impression.

Put some wooden skewers on your table and heat up the stamp material. You need to heat it for at least 30 seconds, and it's important to keep the heat gun moving across the surface so it heats evenly.

You'll notice the surface changes a bit when it starts to get hot. When you're ready, turn off the heat gun and very quickly lay the heated side of the material on the skewers and press really hard. You need to lean into it and press firmly or you won't get a good impression. Lift off the stamp and see what you get.

Apply ink to your stamp with a rubber stamp ink pad or add paint with a brayer. Press it firmly against your surface and then lift it straight up and off.

It takes a little practice to get the hang of how much paint to apply to the stamp, so always make a test print before using it on your finished project.

Moldable stamp material comes in sheets, blocks, and shapes.

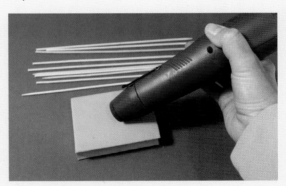

Heat the surface evenly with a heat gun.

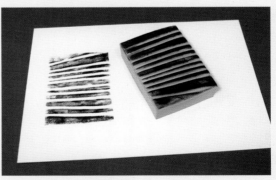

An impression of the molded stamp.

Moldable Stamp Tips

Wash off your stamps as soon as you are finished with them. Residual paint left to dry on the surface may interfere with reimpressing the foam.

Remember that your images will be reverse impressions of the objects you use to create the stamp so anything with raised lettering will be reversed.

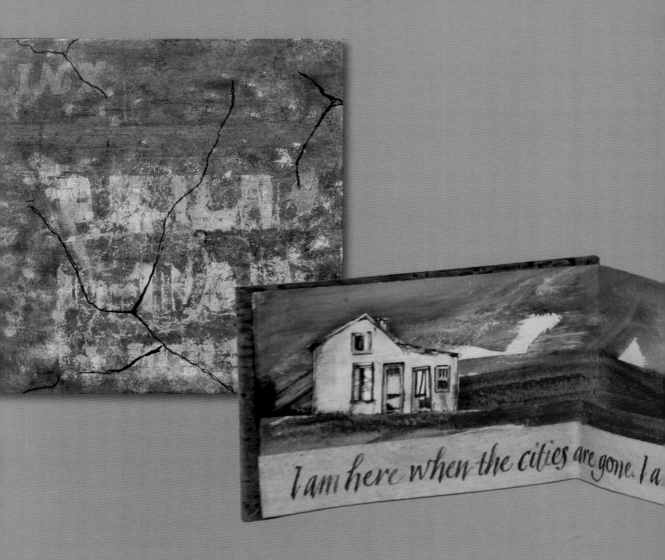

I am here when the cities are gone. I a...

WEATHERED
BEAUTY

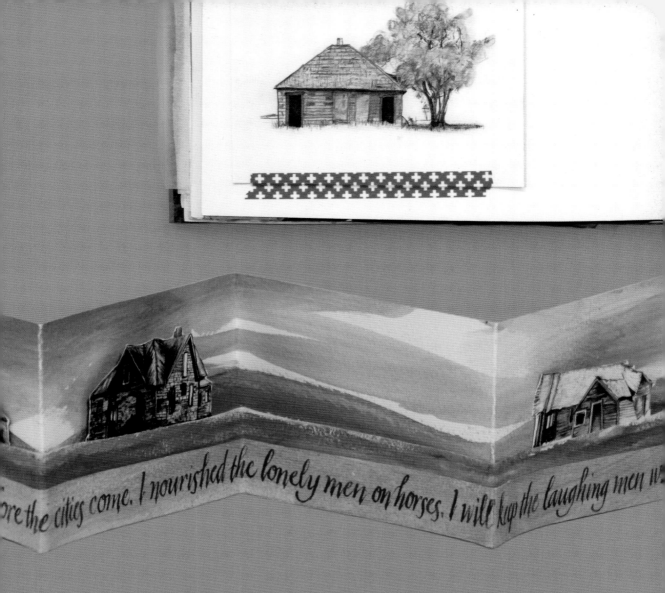

ore the cities come. I nourished the lonely men on horses. I will keep the laughing men w

There is beauty to be found in an aged and weathered surface. Old weathered buildings that stand proudly, refusing to give in to the ravages of time, almost beg to be acknowledged in sketches, paintings, and photographs where they can continue to inspire for years to come.

Artist: **JILL BERRY**

Jill Berry is a mixed-media artist who makes books, paintings, and all things in between. Jill received an art education in Florence, Italy, and has been a graphic designer and painter for twenty-seven years. After designing books for publishers, Jill began creating handmade books in 1997. Her work is content driven with an emphasis on color and text and is often centered on social issues.

Technique Used: **GRAPHITE PENCIL SKETCHING**

Weathered Beauty appealed to me right away, since the subjects of then and now, before and after, young and old, resonate with me at this stage of my life. I find that weathered beauty is in its own category—tried, tested, aged, and still beautiful.

I drew prairie houses because they have long captivated me. My home is in the eastern foothills of the Rockies, where the prairie expands infinitely and flatly to the east and is dotted with abandoned homes. Houses are iconic symbols that I use frequently in my work, because they can be a metaphor for the body as well as physical dwellings that contain what is precious. When I see remote prairie houses, I imagine their stories and guess that most began with dreams for a new life. Families nailed the beams and set the glass for these homes they likely intended to inhabit for quite some time. A great effort was made to haul in wood, stone, glass, and furnishings for these homesteads—none of the materials were available nearby. Babies were born, gardens planted, barns raised, and livestock penned.

Now the homes sit, decaying in their bones and stories, on the plains that surround my home. The curtains still blow in empty frames, and skeletal remains of furnishings are silhouetted in the windows. These prairie houses are sinking into the land that they sit on, taking their stories with them.

Part of what moves me to draw these houses is their setting, usually a wide, empty, and almost bleak vista. Sometimes I find one snuggled against a hill or stand of trees, but not often. Most of the time they are out in the middle of the flat and dry prairie, surrounded by wind. How do you sketch the nothingness?

I went straight to an accordion carousel book (page 138), because it was a form I was familiar with, and it solved the issues I had with this particular subject. I needed layers: the faraway background, the foreground for the houses, and a place for the text. The three-layered nature of this book structure worked perfectly. The houses had a story to tell, so they naturally seemed to fit in a book form.

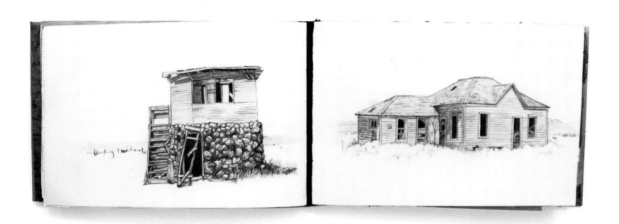

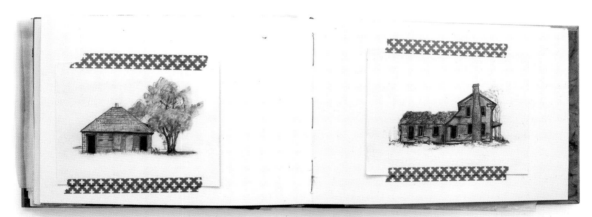

Weathered Beauty sketches by Jill Berry

Cover, Prairie Houses accordion book by Jill Berry (3" x 5" [7.5cm x 12.5cm])

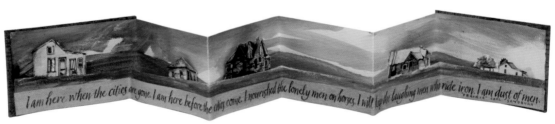

Inside view, Prairie Houses accordion book by Jill Berry

Pencil leads range from hard (light) to soft (dark):

9H 8H 7H 6H 5H 4H 3H 2H HF HB B 2B 3B 4B 5B 6B 7B 8B 9B

HARDEST→ MEDIUM→ SOFTEST

For this project, Jill used 2H through 9B pencils, plus white gel pen and black gouache.

1 Referring to your photograph, lightly sketch in the drawing with 2H to H pencils on hot press watercolor paper (smooth surface). The harder leads have more clay binder, so do not press hard on them because if you do you will emboss the soft watercolor paper. Sketch lightly when using hard pencils.

2 Move to a 2B or 3B to start laying in the contrast, or light and dark elements.

3 Add details with the 3B to 5B pencils. Sketch lightly, dragging the pencil across the paper to use the surface of the paper to add texture. Keep looking at the photo, finding the darkest darks in the shadows, the baseline of the house, and interior areas that have no light at all. Be sure the shadows cast on the house are consistent in their angles.

4 In the final stage, use the soft 9B to get the darkest darks. You can also add black gouache (opaque watercolor) to the darkest areas, and highlight the lightest spots with white gel pen. Be careful of this last detail if your paper is not white. The white pen may end up looking like snow!

5 When you are finished, spray the drawing with a workable fixative to keep the soft graphite from smearing. You can continue to draw on top of the fixative, but the graphite can no longer be erased.

An interesting variation to this technique is to add in a thin wash of watercolor in step 1 and use pencils over that.

To protect graphite drawings from smearing and dust, frame the finished piece behind glass.

Lightly sketch in the drawing.

Start laying in contrast or light and dark elements.

Add details with the 3B to 5B pencils.

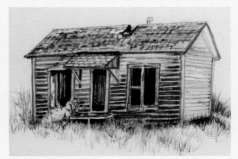

The final drawing.

Artist: **JUDI HURWITT**

With a primary focus on textiles and surface design, Judi chooses varied mediums, which can include anything from fragile, hand-painted threads to metal and stone.

Techniques Used: **STAMPING, PHOTOGRAPHY, SCREEN PRINTING, PEN & INK**

The theme of Weathered Beauty excited me because I wanted to try to capture it in a very literal way, but it also intimidated me a little because I'm an abstract artist who doesn't usually work figuratively.

I started with a photograph. When I travel, I obsessively photograph battered walls, stairs, roads, houses . . . anything that shows wear, layers of peeling paint, and decay. While on a recent trip to Pennsylvania, I photographed a stone retaining wall that runs along the banks of the Schuylkill River. To me, the walls covered in thirties- and forties-era hand-painted signs, faded and mostly illegible now, epitomize the theme of Weathered Beauty, and I decided to try to reproduce the sense of antiquity and grunge those walls evoke. I worked directly from my photograph.

I knew I wanted a heavily layered surface, which I intended to build up from a black acrylic underpainting to the dingy gray of the actual wall color, so a thick, sturdy watercolor paper was necessary. That necessity informed my choice of sketchbooks for this piece.

I am an abstract artist, not particularly adept at drawing. Working literally is a little scary for me but I wanted to capture the true nature of these amazing stone walls, so I knew I would have to face the challenge of not running back to my abstract roots to depict them. I worked past my fears by giving myself permission to remake the art as many times as needed to achieve the look I wanted. Once I freed myself to experiment, it all came together rather nicely.

I decided on the layering techniques I wanted to employ, the color palette I wanted to use, and had the design elements placed where I wanted them, then it was time to move on to a stretched canvas.

For my first attempt, I chose a small stretched canvas with a lovely 2-inch reveal that would give the piece depth when it hung on the wall. After priming the canvas, I applied layers and washes of acrylic paint and Thermofax screening just as I had in the original sketchbook piece. I find that using thinned fluid acrylic in successive layers creates wonderful

Weathered Beauty sketchbook page by Judi Hurwitt

depth and texture, and this piece of art contains upward of twenty layers.

Once the wall itself was completed, I worked back into the canvas along one side and across the bottom with bright greens, yellows, and white heavy-body acrylics to add a "foliage" underpainting. I painted several deli papers in the same colors, cut them into leaf shapes, and adhered each leaf to the foliage underpainting with a dot of glue. This added a lot of lovely depth, movement, and texture to the piece, but it also distracted too much from the wall itself.

Unhappy with the final work, I started again with a new plan: I would create just the wall and leave any indications of foliage off altogether.

The second piece (right) was painted on a heavily weathered piece of ¼-inch plywood using the layering technique previously discussed. Leaving the foliage out of the work focused the piece and made the weathering the true star.

Keeping a Sketchbook While Traveling

You never know when inspiration will strike so make it a point to always have a sketchbook and pen with you when you leave the house. If you find yourself packing for a trip abroad, you may want to bring a few additional supplies with you such as:

- Watercolor pencils and water brush

- Small watercolor set

- A few colored markers

- Crayons

- Glue sticks for pasting in ephemera

Paste an envelope into the back of your sketchbook to tuck in bits of found papers or other objects for using later.

Tamaqua panel by Judi Hurwitt (12" x 12" [30.5cm x 30.5cm])

CONTRIBUTING ARTISTS

Jill Berry
http://jillberrydesign.com/

Sue Bleiweiss
www.suebleiweiss.com

Jackie Bowcutt
http://stitchworks-jackie.blogspot.com

Laura Cater-Woods
www.cater-woods.com

Violette Clark
www.violette.ca

Jane Davies
www.janedaviesstudios.com

Jamie Fingal
www.jamiefingaldesigns.com

Judi Hurwitt
www.approachable-art.blogspot.com

Tracie Lyn Huskamp
www.thereddoor-studio.blogspot.com/

Leslie Tucker Jenison
www.leslietuckerjenison.blogspot.com/

Lyric Kinard
www.lyrickinard.com

Susan Brubaker Knapp
www.bluemoonriver.com

Lynn Krawczyk
www.fibraartysta.com

Jane LaFazio
www.PlainJaneStudio.com

Kim Rae Nugent
www.kimraenugent.com

Kelli Nina Perkins
www.ephemeralalchemy.blogspot.com/

Carol Sloan
www.carolbsloan.blogspot.com/

Carla Sonheim
www.carlasonheim.wordpress.com/

Kathy Sperino
www.finishinglinesbyksperino.blogspot.com/

Diana Trout
www.dianatrout.com

Kathyanne White
www.kathyannewhite.com

ADDITIONAL ARTWORK BY

Jill Booker
www.prairiejill.blogspot.com/

Dion Fowler
www.diondior.blogspot.com/

Daniel T. Haase
www.about.me/dthaase

Gina Macioce
www.flickr.com/photos/livelife28/

Kathleen Murphy
www.kathleenmurphydesigns.blogspot.com/

Catherine Parkinson
www.catherineparkinson.blogspot.com/

Dana Strickland
www.flickr.com/photos/31316409@N02

Sharing Your Sketchbook with Others:

Did you know that the Sketchbook Challenge has a dedicated Flickr group where you can share photos of your sketchbook pages with artists from all over the world? You'll find it at www.flickr.com/groups/sketchbookchallenge/.

RESOURCES

All of the techniques in this book call for materials that are readily available in most art or craft supply stores. The following list of suppliers will help you find all the materials you need to experiment with the techniques in this book.

GENERAL

Artist Cellar
www.artistcellar.com

Dharma Trading
www.dharmatrading.com

Dick Blick
www.dickblick.com

Joggles
www.joggles.com

BOOKBINDING SUPPLIES

Hollanders
http://hollanders.com/

DYES, SOY WAX

Pro Chemical and Dye
www.prochemicalanddye.com

FUSIBLE WEBBING

Mistyfuse
www.mistyfuse.com

IMAGE TRANSFER MEDIUM

Citrasolv
www.citra-solv.com

MICRON PENS

Sakura
http://sakuraofamerica.com/

PAPER

Hollanders
http://hollanders.com/

The Paper Studio
www.paperstudio.com/

Strathmore Artist Papers
www.strathmoreartist.com

SILK SCREENS

EZ Screen Print
http://ezscreenprint.com

Marcy Tilton
http://marcytilton.com/

TEXTILE FOILS

Laura Murray Designs
www.lauramurraydesigns.com

THERMOFAX SCREEN SERVICES

Fibra Artysta
www.fibraartysta.com

WEBSITES OF INTEREST

The Sketchbook Challenge, www.sketchbookchallenge.com

The sketchbook challenge Flickr group, www.flickr.com/groups/sketchbookchallenge/

Free projects from Sue Bleiweiss, http://suebleiweiss.com/blog/free-projects/

Paula Burch's all about hand dying, www.pburch.net/dyeing.shtml

Random Word Generator, http://watchout4snakes.com/creativitytools/RandomWord/RandomWordPlus.aspx

FOR FURTHER READING

Berry, Jill. *Personal Geographies: Explorations in Mixed-Media Mapmaking.* North Light, 2011.

Clark, Violette. *Journal Bliss: Creative Prompts to Unleash Your Inner Eccentric.* North Light, 2009.

Davies, Jane. *Collage Journeys: A Practical Guide to Creating Personal Artwork.* Watson-Guptill, 2008.

Davies, Jane. *Collage with Color: Create Unique, Expressive Collages in Vibrant Color.* Watson-Guptill, 2005.

Kinard, Lyric. *art + quilt: Design Principles and Creativity Exercises.* Interweave Press, 2009.

Perkins, Kelli Nina. *Stitch Alchemy: Combining Fabric and Paper for Mixed-Media Art.* Interweave Press, 2009.

Sonheim, Carla. *Drawing Lab for Mixed-Media Artists: 52 Creative Exercises to Make Drawing Fun.* Quarry, 2010.

Trout, Diana. *Journal Spilling: Mixed Media Techniques for Free Expression.* North Light, 2009.

White, Kathyanne. *Designing Intriguing Surfaces.* Amazon Digital Services, 2011.